ON THIS EARTH

# ON THIS EARTH
### PHOTOGRAPHS FROM EAST AFRICA BY **NICK BRANDT**

#### FOREWORD BY ALICE SEBOLD   INTRODUCTION BY JANE GOODALL

**CHRONICLE BOOKS**

SAN FRANCISCO

For Orla—
who I'm eternally grateful is also on this earth.

# FOREWORD

BY ALICE SEBOLD

Dust shimmers off an elephant like confectioners' sugar; you can almost feel his huge feet hit home. The profile of a lion has the haunting resonance of the photographs of Civil War generals long dead, and in the face of a chimpanzee is the depth of an unknowable wisdom.

There are the two shadowy lionesses in what appears to be a roiling storm, and a pride asleep with one assigned protection. The elephant standing, her child beneath her belly, as mythic and historical as any Madonna. The long march, like that of the Lost Boys of the Sudan, of animals across an endless plain. A cheetah in the branches of an acacia tree. The architectural surprise of a giraffe's upper body exploding from the grass. And a zebra, unhumbled in a human doorway.

The animals are the subject; their natural world the frame.

The photographs of Nick Brandt are both beautiful and haunting. They come upon you in a flush of abundance that it is almost hard to recover from. When I first saw his photographs I grew very quiet, because Brandt's reverence for his subjects was so immediately clear. I was very aware both that Brandt understands there is a division between photographer and subject, and that he wishes deeply, somehow, that there wouldn't be. He knows, as we all must, that it is this division that has wreaked so much terror in the world of his subjects.

Much like Philo Farnsworth, the seventeen-year-old who invented television—which he is said to have envisioned while watching the rhythmic flow of the Utah fields he farmed—Nick Brandt believes in the power of images to move us. Farnsworth prophesied that if people in one part of the world could see people in another part of the world and see how similar we all are, there would be no war. Sheer idealism, we cynically say now, but if we condemn the highest goal of communion, what have we achieved? A temporary protection from mortality? The right to call ourselves supreme? Nick Brandt is documenting a world apart, and, though he knows in his soul it is a world disappearing daily, he is also sending up a song in his grief.

I have never been to Africa, and almost all the animals in this collection I have never seen in the flesh (those I have seen were certainly not in their natural habitat). But I am someone who gains insight, as many of us do, by making comparisons. These photographs strike chords in me, resounding off prior images and those images' attendant histories.

I start with my sugary elephant, one of the many pure gifts of this collection. The heavy rumble of his pace and the way the dust lifts off him in clouds. And how he seems larger than the mountains and the sky, traveling within his own shadow—the sun floating directly overhead. How did Brandt have the wherewithal to get that shot? (A question I have of many of these photographs!)

Perhaps Brandt had already spent days or weeks or months with his mouth open in wonder. Or perhaps, as is the photographer's blessing and curse, taking the animal's picture was the only way for him to feel that he had truly seen what he had. We are the lucky ones, in that Brandt is driven not only to take these portraits but to share them. I look at that elephant and I think of sweetness—that fine powdered sugar—and of power—the thunder of the feet. Brandt's elephant is a being with a destiny ahead of him, led forward by the soft ivory curve of his tusks. He is

myth and he is childhood dream all at once. What is most amazing is to know that he is real—of blood and of bone, as we are.

The profiles—the thoughtful zebra, the lions—both in close portrait and whole-body shots; the rhino with his incredible horns and his resigned, downcast glance; the three-quarter profile of the chimpanzee clutching his chest and looking off into the distance: these are just a few of what I would call Brandt's Portraits of Generals. Even the borders here often fade and burn the way old portraits of Civil War generals in the 1860s did. And their eyes have the look of sacrifice and wisdom, determination and, yes, loss. Do I anthropomorphize them when I indulge in comparison? Guilty, yes. And yet, in words I cannot hope to offer them as purely, as honestly, as unfettered as Brandt's photographs have, I do see them as unwilling generals in a fight very different from that of bringing food home to their young. They are representatives that we now have before us to preserve their history, and to make, perhaps, a last stand on the battle lines to keep from being destroyed.

What we know—because, I hope, we are not blind, because we take on the domestic animal or the bird fallen from the nest or doe caught in barbed wire in our fields—is that the life of the animal and the life of man are intertwined. This leads me to Brandt's shots of the wider plains. I look at the two photographs of masses of elephants and I cannot help but think of the photographs I have seen of the Lost Boys of the Sudan marching, forever marching, to find a home. Because there are people who too understand what it is to be robbed continually of habitat, to be cast out without thought.

Then, turning, Brandt gives us the luxurious beauties of the hippos. Here Brandt is the man who has stumbled across them swimming in their truly heavenly watering hole. As he takes their picture, the action is at the shoreline, where it looks like a few smaller hippos and their attendants are having a game of splash. Has one ever seen a game of splash in quite this setting?! The eye lifts up from the focal point of hippo activity and sees all the visual levels in this photograph. There are hippos, too, in the distance, beyond the curve, and the lushness of clouds in the sky and of trees on the banks and, almost unbelievably, the lushness of the cliff and shore.

It is impossible to mention all the photographs here—that abundance I mentioned before—but what I must say is that Brandt's work exists on so many levels that we cannot help but answer the invitation he has issued us. If you are a lover of shape, look at the almost fashion-photograph curve of the close-up of a cheetah as he swivels and stares out over his back, or the lovely space between the kudu's ears (you can almost feel them quiver) in a three-quarter portrait from the rear (and can I just say—look at those eyes!). If you are a lover of form and architecture, look at that unfolding angled fan of giraffe necks with the moon up overhead. Look at the animals in the doorways—both a giraffe ("Hello, human, what are you thinking, doing, going to be?") and a coltish zebra, the curve of each doorway gently containing the wild beast.

Perhaps you are weak, as I am, a lover of narrative and story. Perhaps you also try to imagine the unimaginable, while still holding what you play with in your mind in absolute awe.

Because I believe this is possible, is necessary, for a sustained relationship between the wild and the unwild—sheer respect eventually ends up in guaranteed distance and disassociation and separation, to the benefit of neither wild nor unwild.

You have to maintain a sense of play, of possibility, of a world where . . .

It is a very long time from now. Eighty years. Or a thousand. Somehow an English manor home has been plunked down on a distant plain where there is constant fog. The house has a storybook quality—almost symmetrical, with double chimneys from which in winter once threaded delicate smoke. In the yard is the child whose toy this house is. He stands knock-kneed yet erect—a giraffe—and he glances off to the side, unthreatened by the interest of this weird-looking mammal holding a camera. Later the giraffe and his friends might play a game of doorway with the tenants of the house—the ghosts of humans who, sadly, are long gone. They flit in and out of the rooms, having tea, trying on their—strange things!—clothes, and talking—about what?—we can't know. Then the giraffe will leave his English manor toy behind for a while and move into his larger world, the world as it first began, as it is most beautiful, most fragile, most threatened, as it is most reverently and playfully and lovingly testified to in the work of that strange, gifted creature, this human man with his camera! The giraffes will give him the toy manor house to live in.

They know he is precious. They will treat him right . . .

You are about to enter a world of the imagination, where all the animals are real, both fragile and full of grace.

# INTRODUCTION

BY JANE GOODALL

When I am in a wilderness area—whether it be forest, savannah, wetlands, or mountains—and especially if I am by myself, I so often experience a sense of awe at the beauty of creation, the sacredness of life. The photographs in this book inspire similar feelings.

The first time I saw Nick Brandt's pictures, I felt emotionally involved. Gazing at some of the images, such as those of the cheetah standing in the fork of an acacia tree, the storks roosting in the upper branches of a grove of trees, and the wildebeest crossing the Mara River, I found I was caught up in the experience of the photographer. It was as though I was sharing that moment when animals and landscape merged into one exquisite whole, the moment when the image was captured.

Nick has focused on the photography of wildlife and the natural world of Africa as an art form. Many of his images have the magnificent composition of a classical landscape painting: the image of hippos gathered near the banks of a river, for example, is reminiscent of a landscape by the nineteenth-century English painter John Constable. And many of his close-ups look as if the animal has agreed to pose for a studio portrait—especially the photographs of the chimpanzees and lions. Yet not only were these animals wild and free, but Nick did not even use a telephoto lens; instead, he relied on his patience and ability to quietly, unobtrusively reveal each subject's true image.

Nick has captured the individuality of his animal subjects—it is almost impossible to look through this book without sensing the personalities of the beings he has photographed. I think I knew from the very beginning that the lives of individual animals mattered and had meaning in the great scheme of things. My forty-five years of learning about and learning from chimpanzees has only strengthened this conviction—as do Nick's photographs. Look at the intelligence and self-awareness that gleams in the eyes of the chimpanzees. Sense the absolute self-confidence of the lions—especially the lioness who gazes out over her hunting grounds, supremely aware of her own power.

Do animals have souls? During my many years alone in the forests of Africa, I felt very close to a great spiritual power. It seemed to be all around. I came to believe that there is a spark of that spiritual power in all living things. With our highly developed intellect and our unique ability to communicate using a sophisticated spoken language, we humans are able to question the meaning of our lives on Earth. I came to believe that the spark of the Great Spirit that I sense in myself is my soul. Looking at some of these photographs reinforces my belief that animals, like us, have souls. Indeed, this whole book brings to mind the worldview of the indigenous people: a spiritual and poetic understanding of the natural world in which animals, nature, and the self are one. I think this is why the photographs arouse such deep emotions—it is unthinkable that such beauty should vanish from the planet.

Yet that is exactly what is happening. Every day vast areas of the natural world fall to bulldozers and chainsaws in the name of progress or corporate greed. The remaining wilderness is constantly being nibbled away due to human population growth,

often by people living in poverty who must raze wilderness areas to grow crops or graze livestock in order to survive; as a result, droughts and floods get worse. Industrialization in its many forms is polluting, poisoning, the Earth, the air, the ground. Our heedless use of fossil fuels is massively contributing to global climate change, causing the ice at the poles to melt. Everywhere people as well as animals are suffering.

And, even as the human species is growing in numbers, other animal species are disappearing. Every day at least one life form becomes extinct—gone forever. Even though the vanished species may be a small, seemingly insignificant creature, areas of wilderness comprise hundreds of diverse forms of life, each one depending on others for its survival. So each loss weakens the whole. We are tearing the net whose interwoven strands support life, as we know it, on Earth.

And it is not just the small creatures and plants that are in danger. Even some of the magnificent creatures portrayed in Nick's book are threatened with extinction, especially the chimpanzees. And, not only that, animals are subjected to horrid cruelty—in inhumane zoos, in circuses and other forms of entertainment, and in medical research laboratories. They are hunted for "sport," for food, for their furs. Our exploitation of animals is shocking and endless.

These problems seem huge, but fortunately many groups and individuals are answering the unspoken plea for help. Together we can, indeed must, help prevent further damage and improve the quality of—and respect for—life on Earth.

How tragic it would be if future generations gazed at the heartbreaking beauty of these portraits knowing that they would never see these animals in the wild. Thank you, Nick, for your dedication and talent, your insight and patience. For these photographs, by emphasizing the importance of each living being, will surely inspire others to join our cause and help to stop our senseless destruction of life and beauty before it is too late.

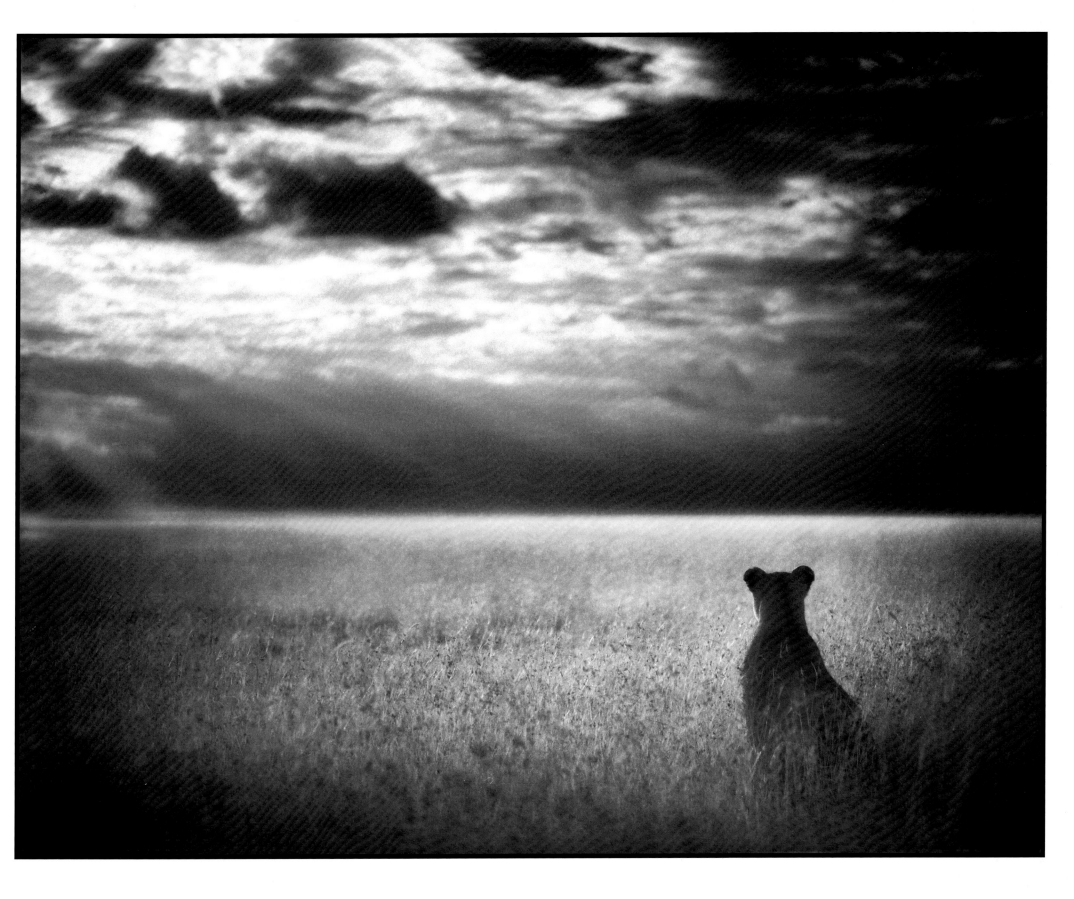

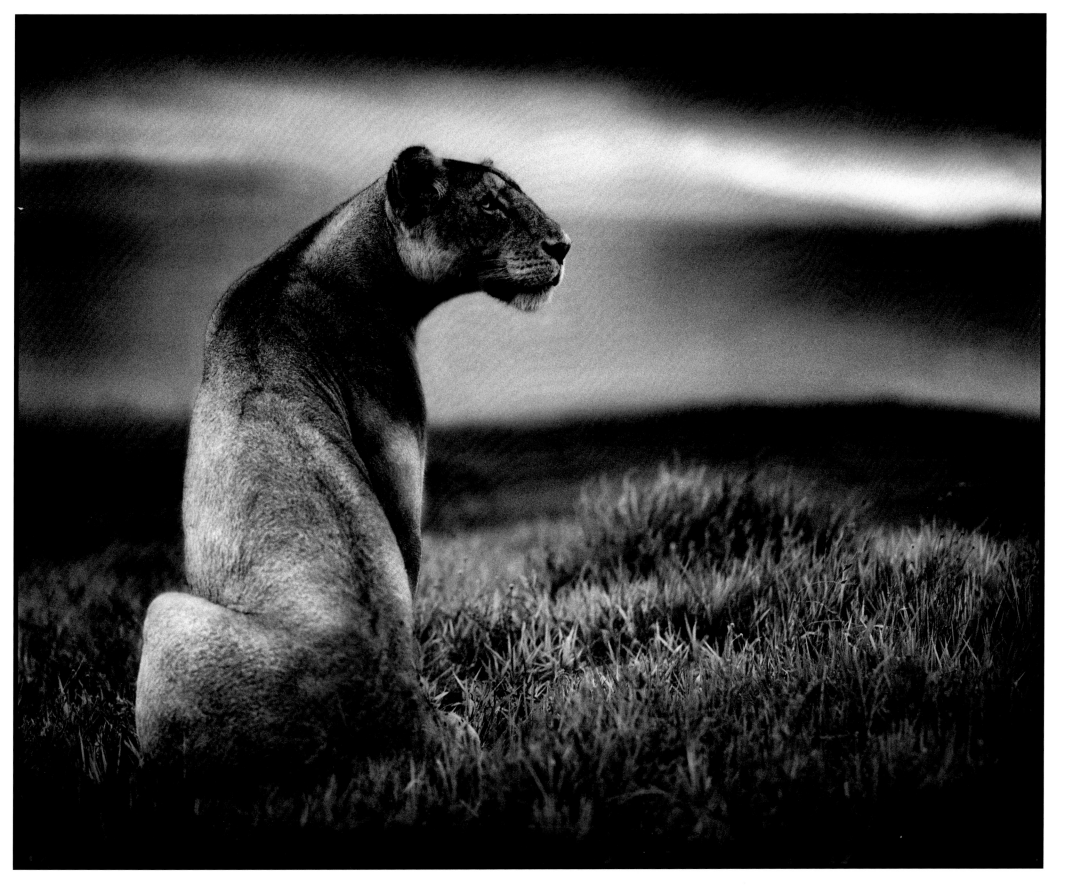

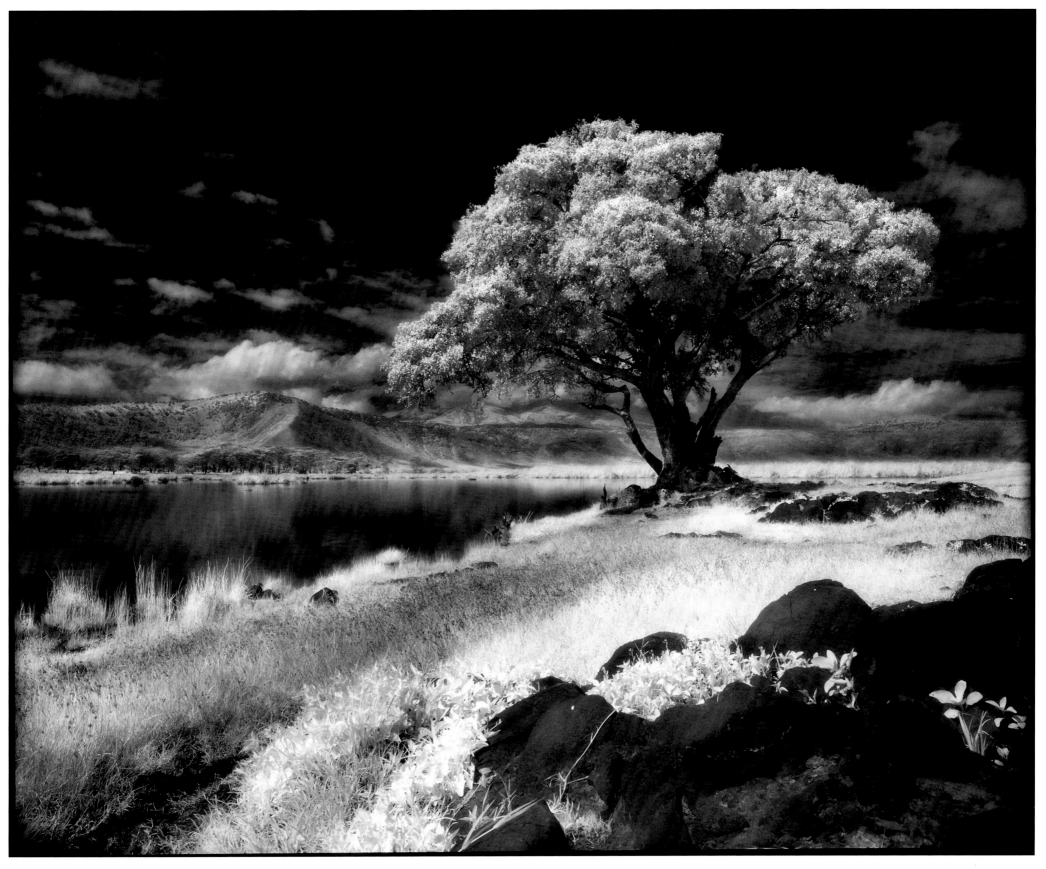

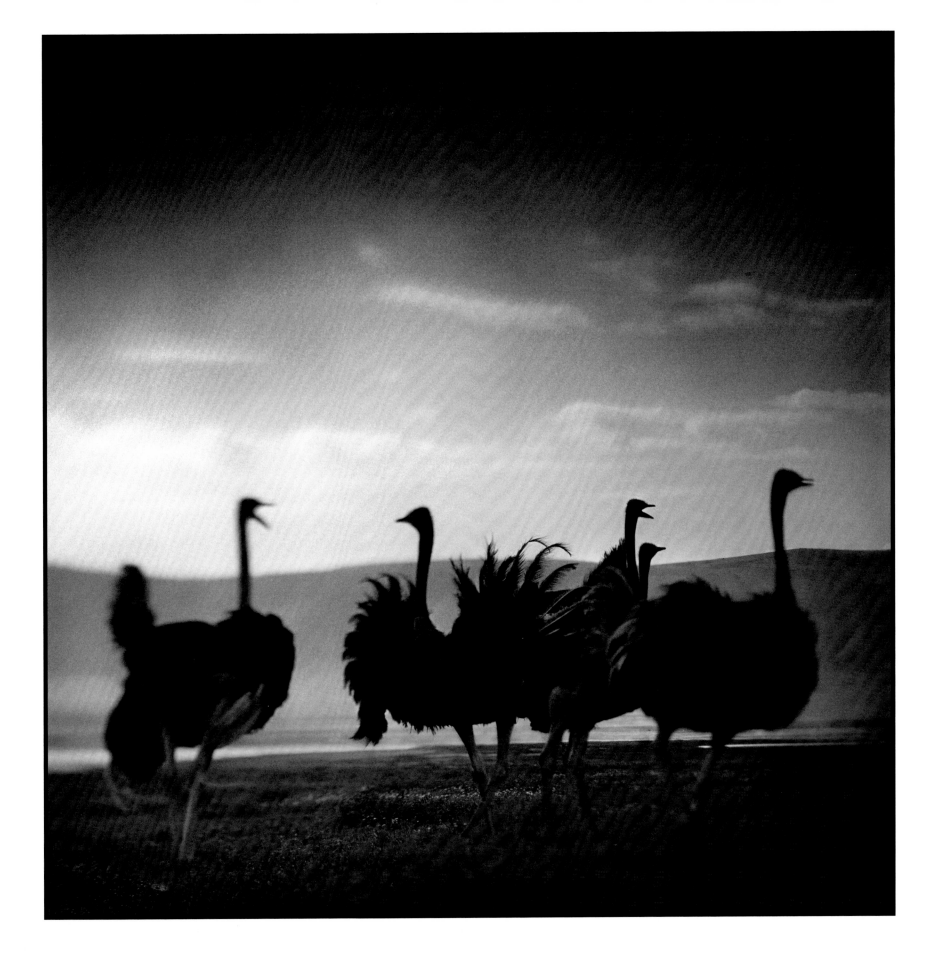

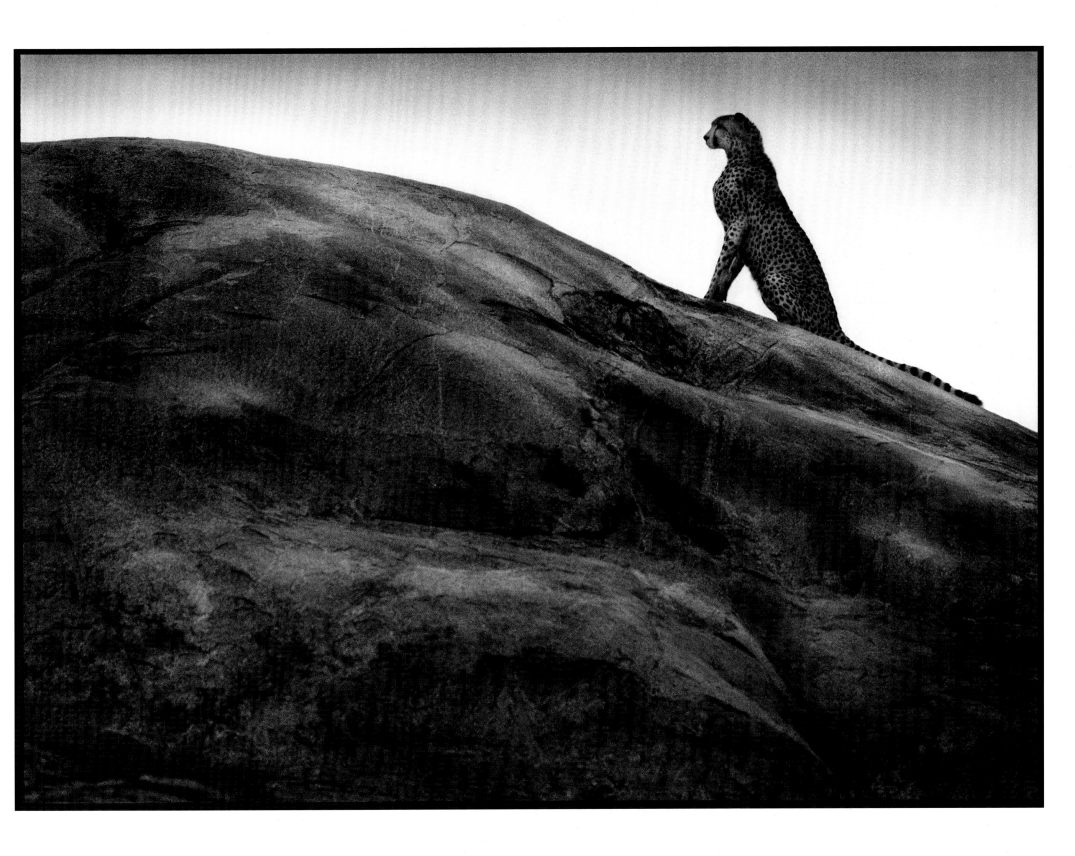

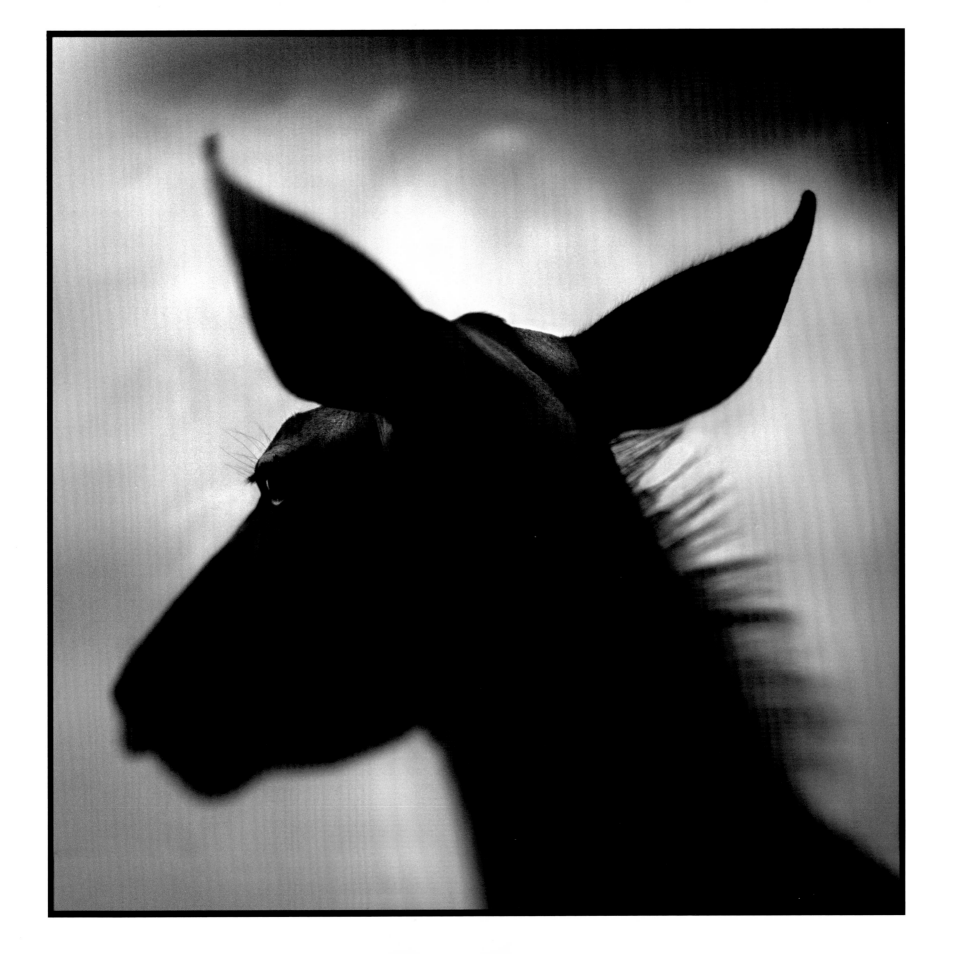

23

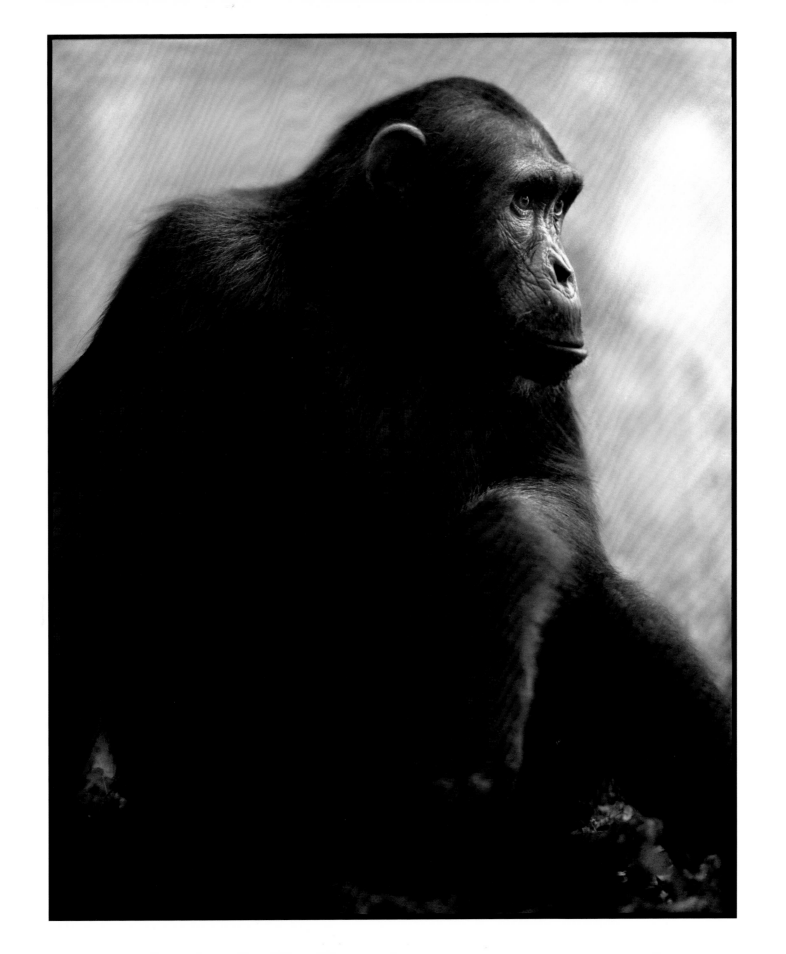

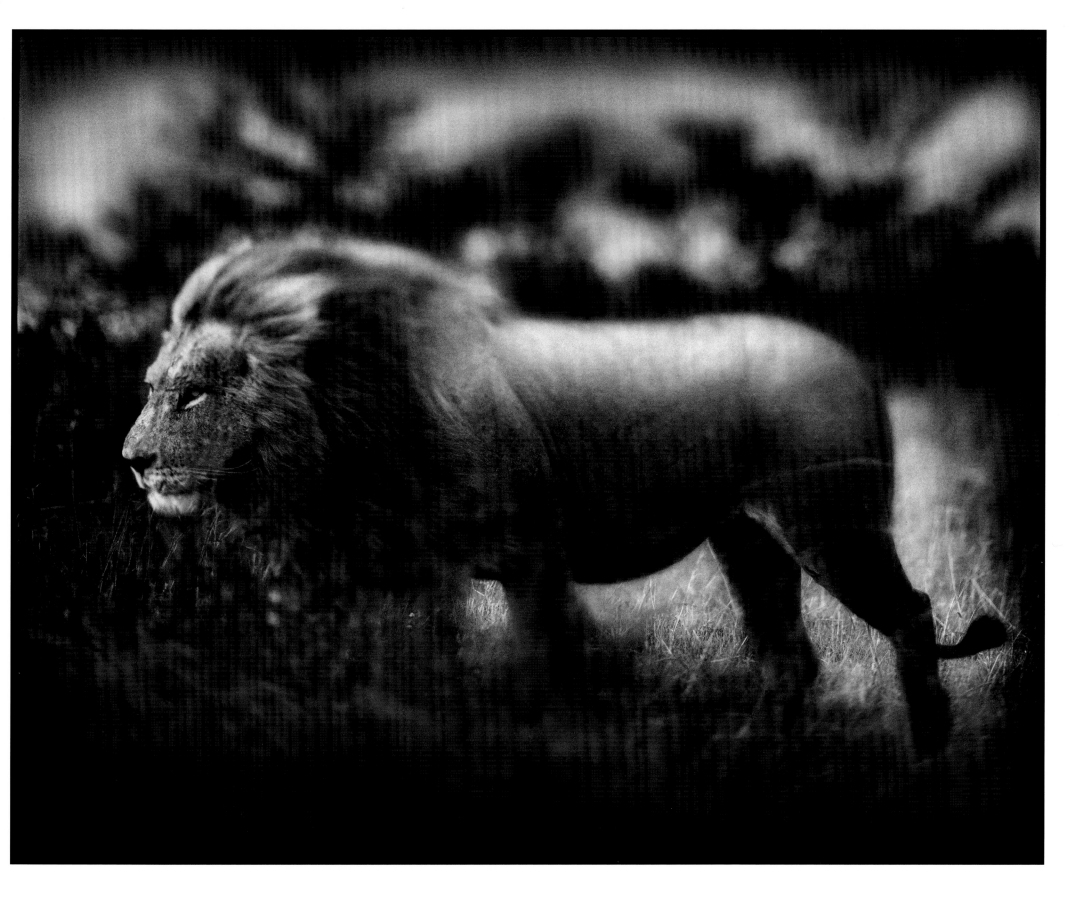

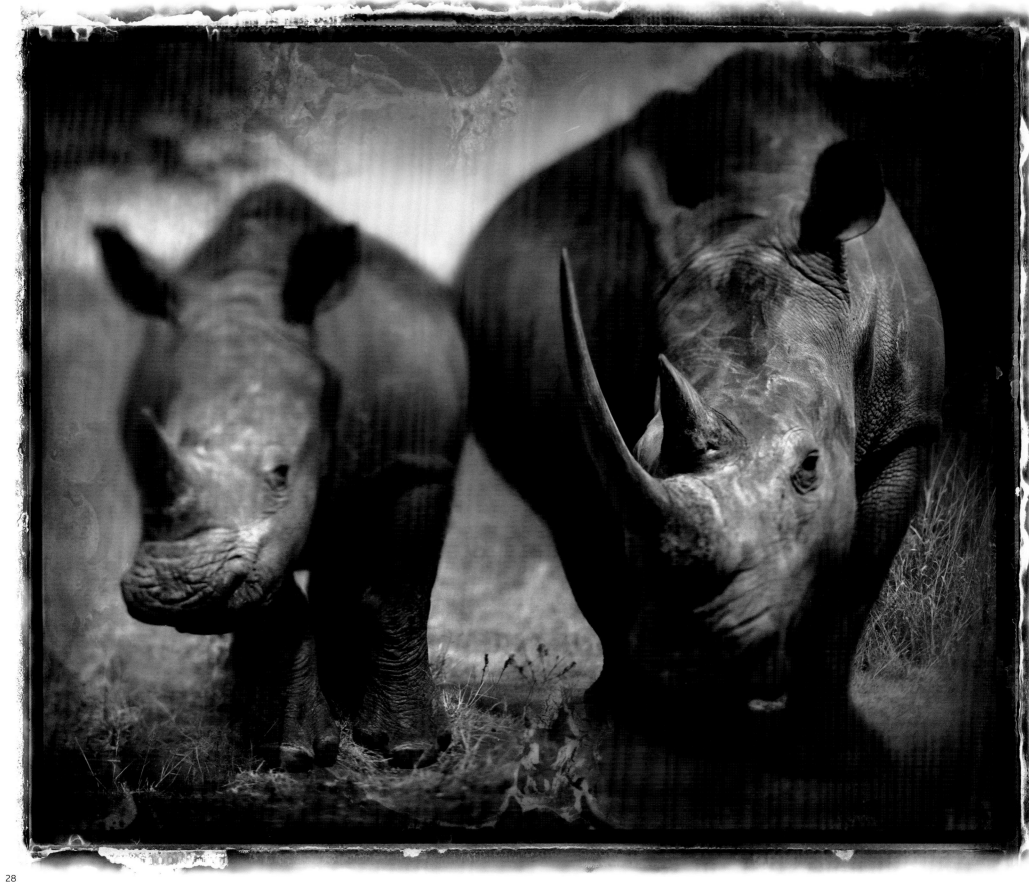

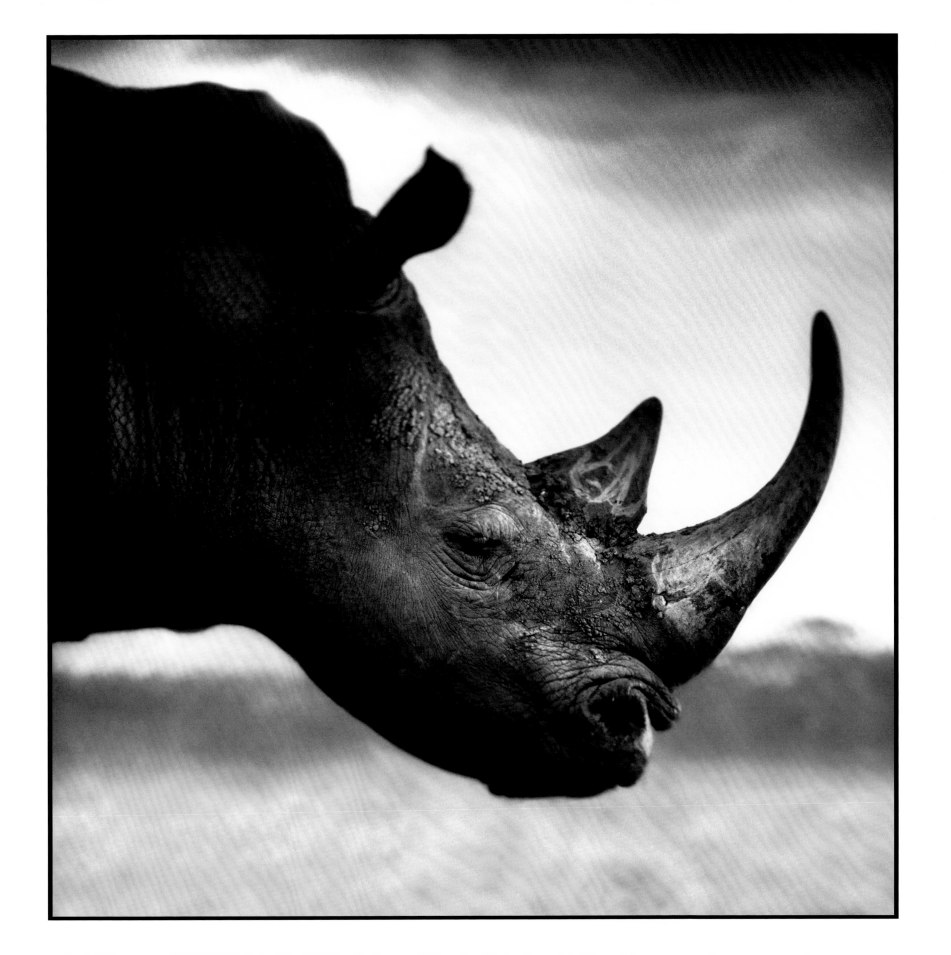

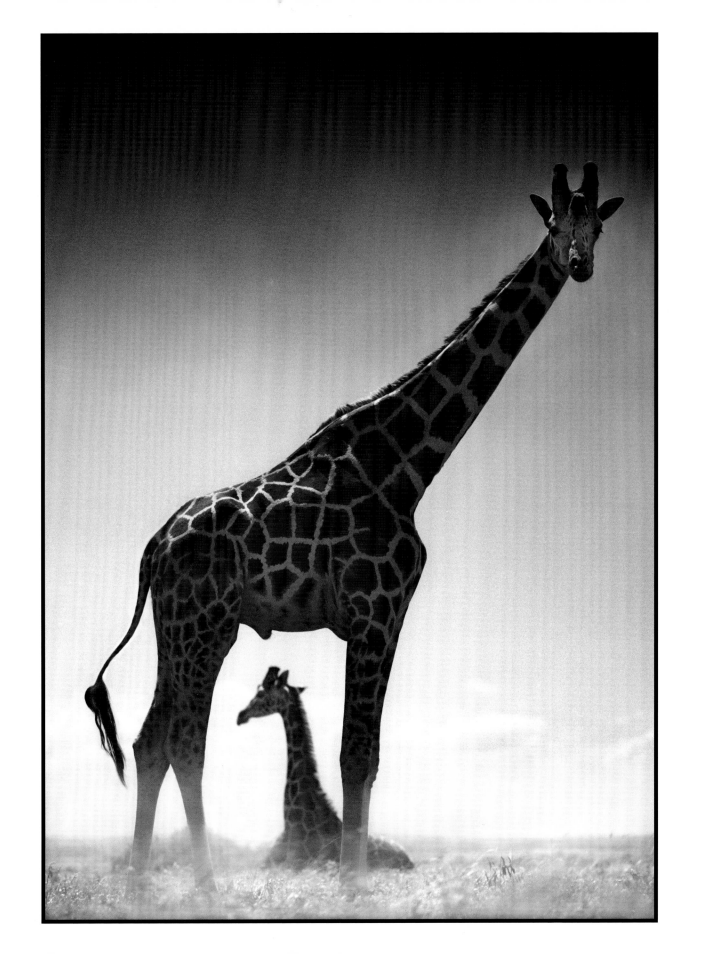

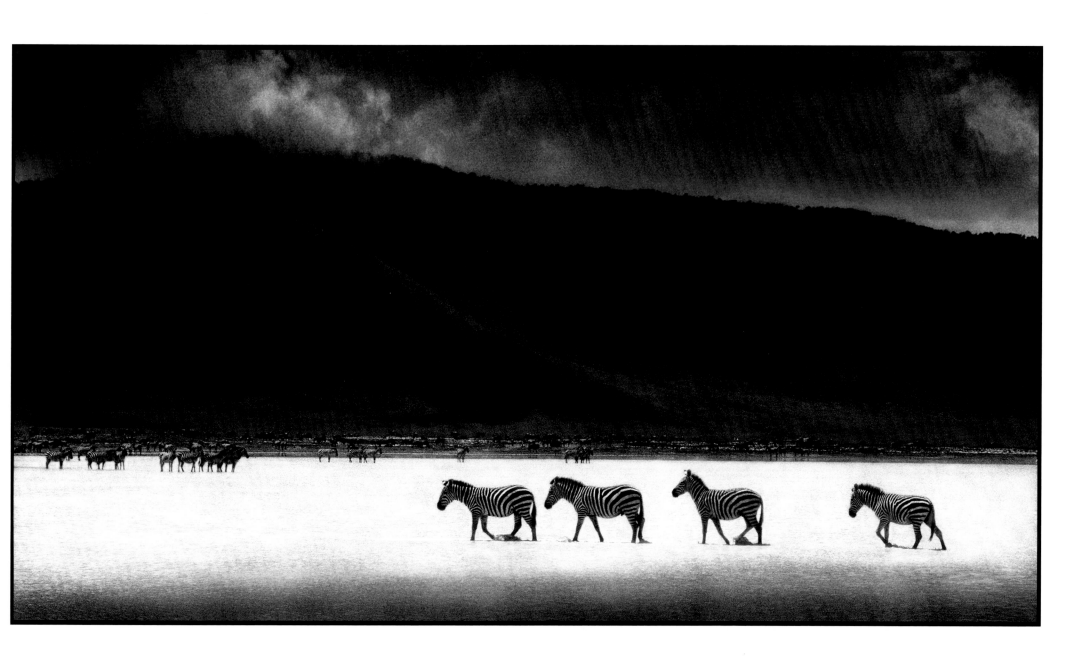

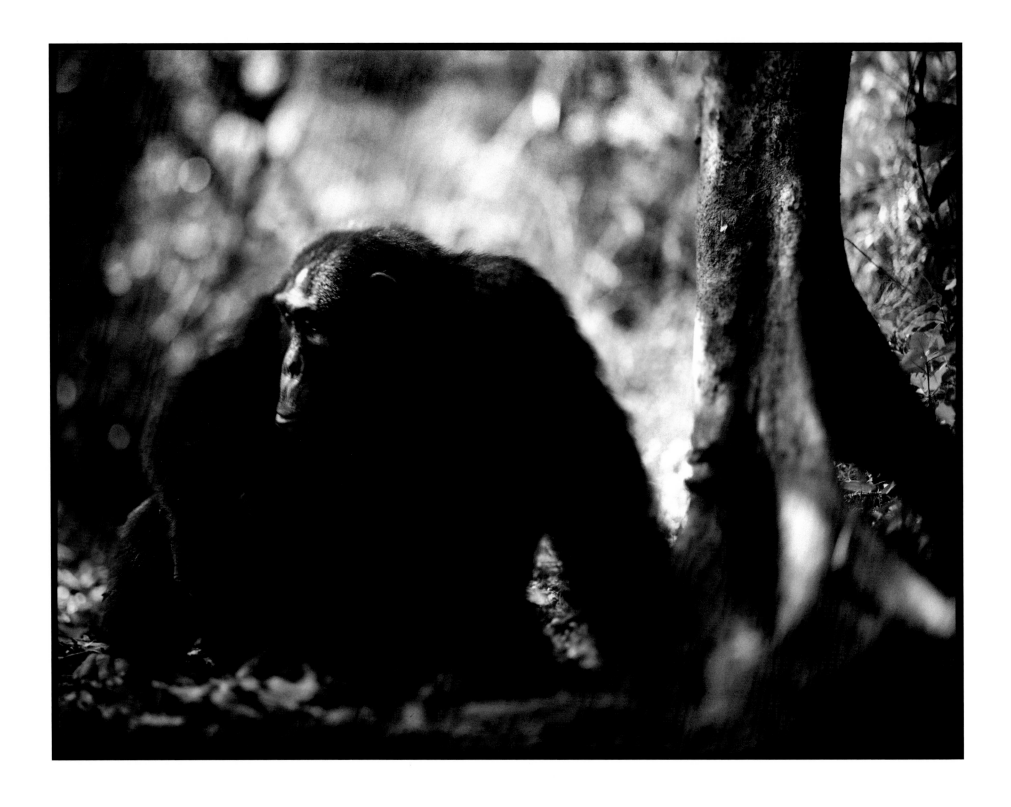

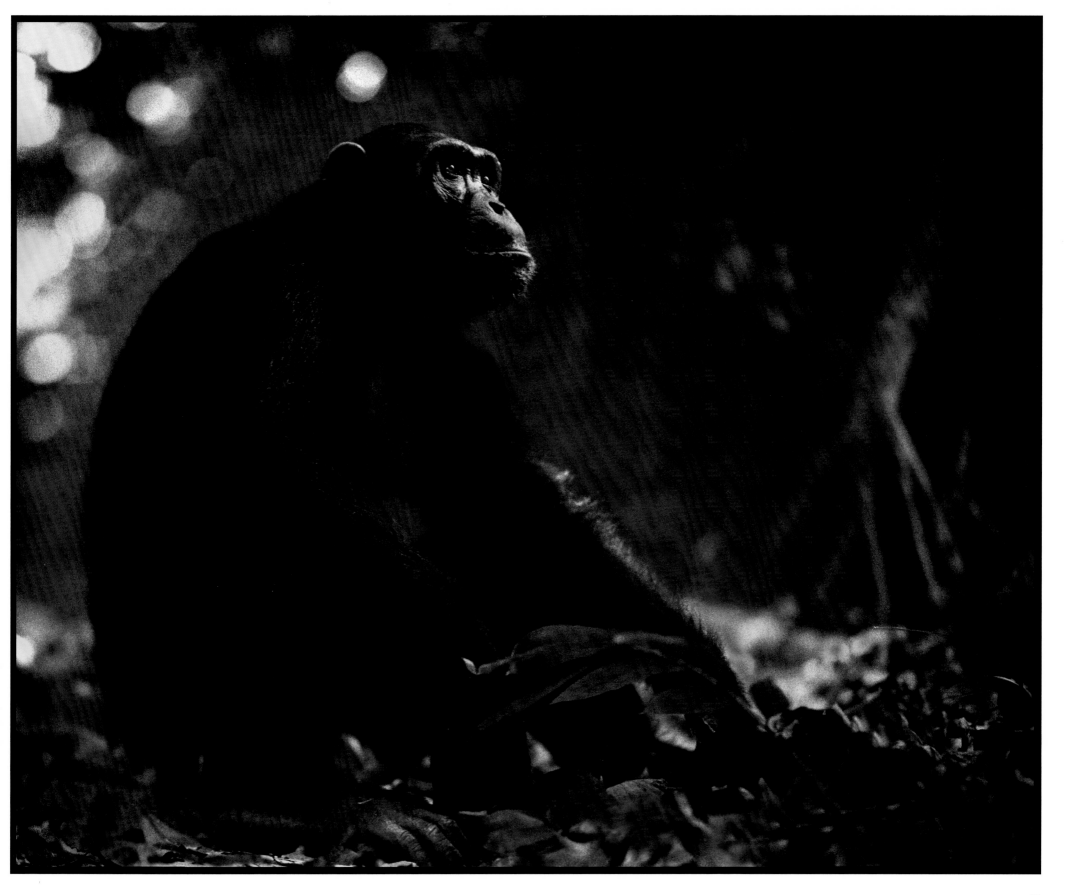

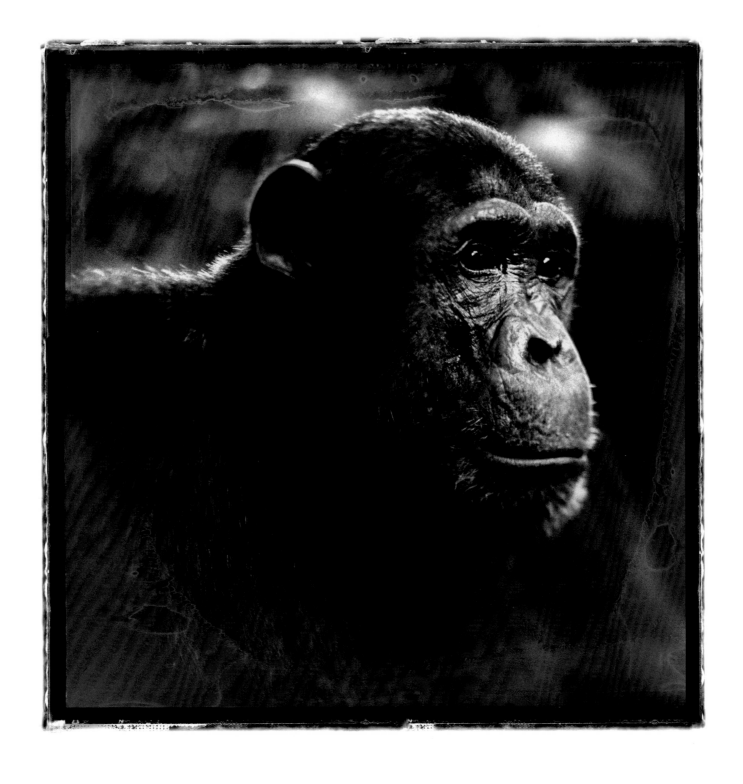

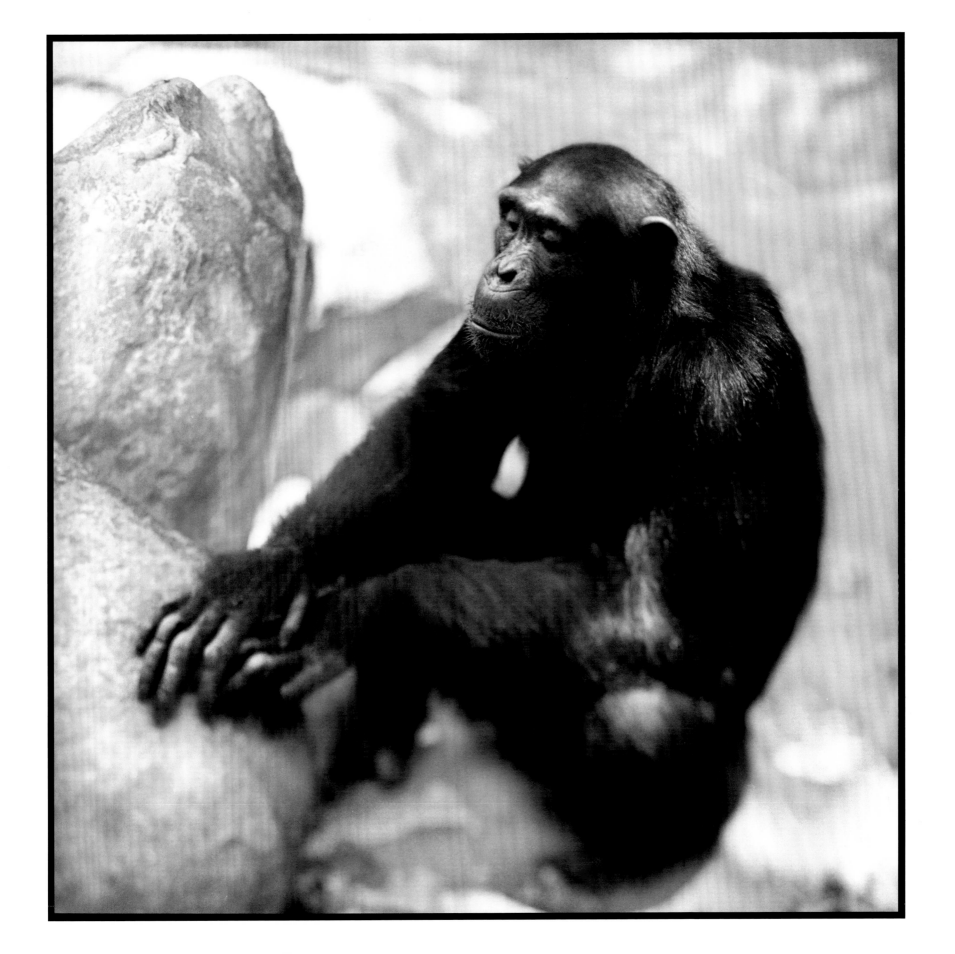

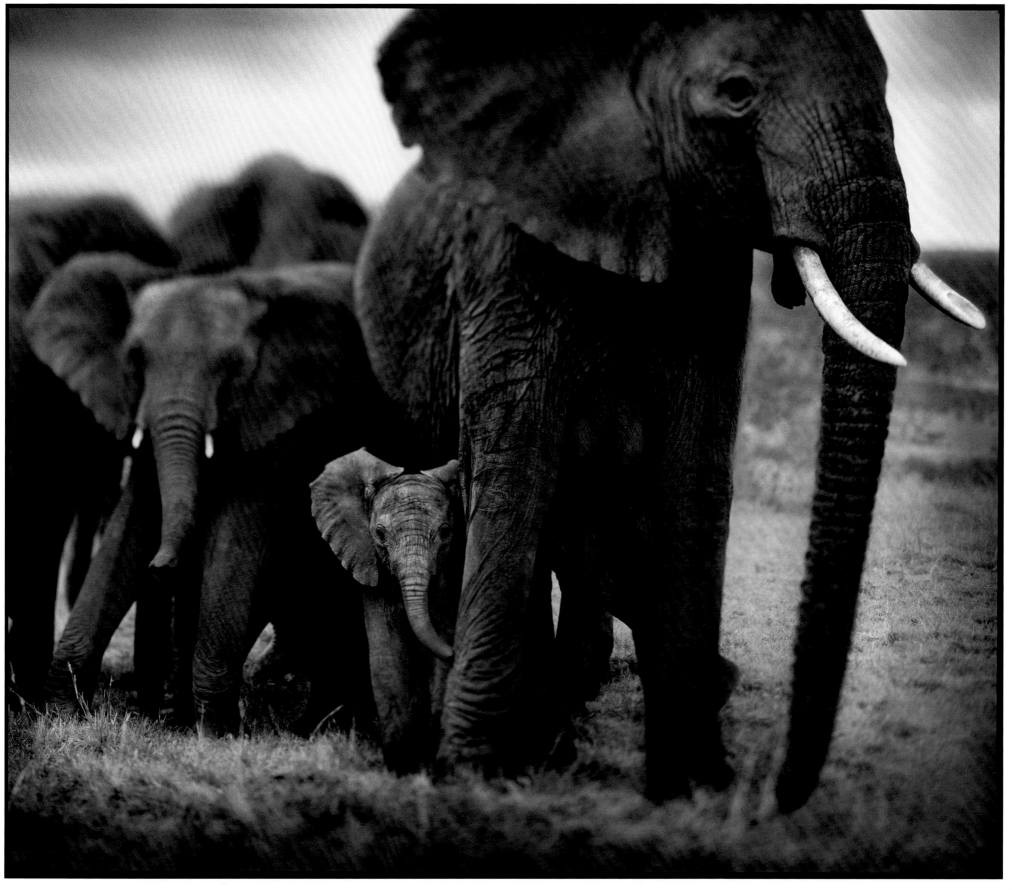

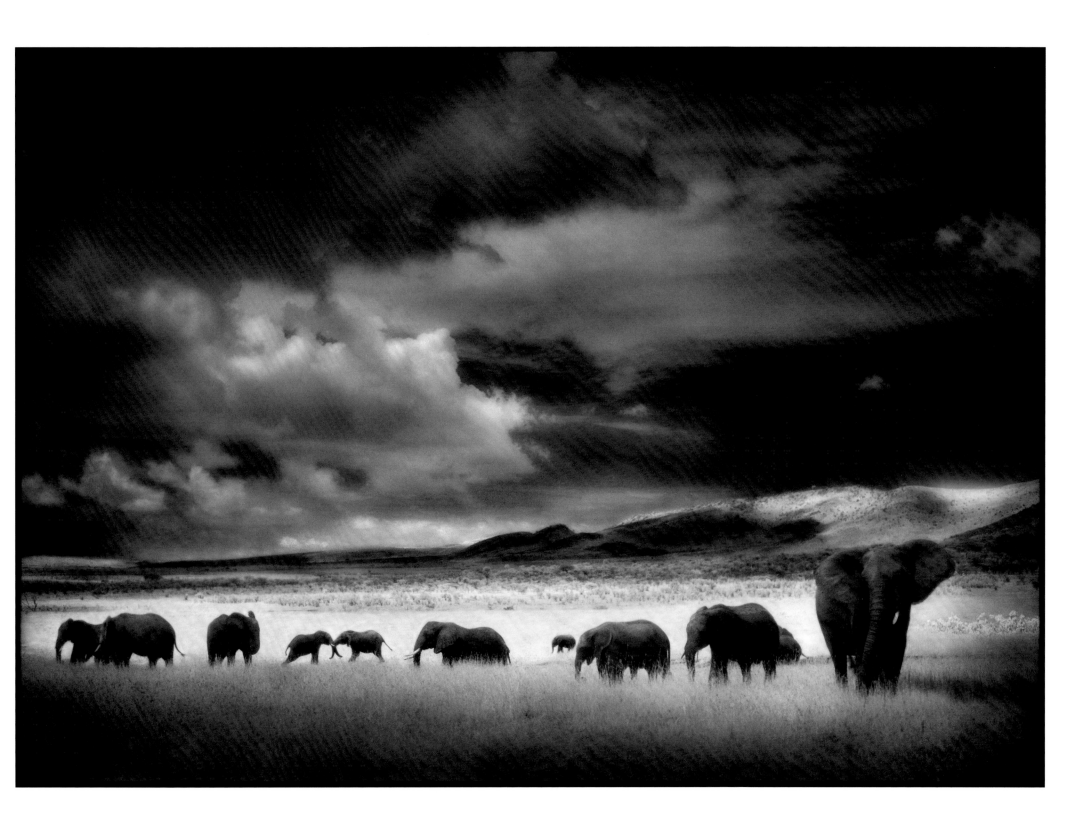

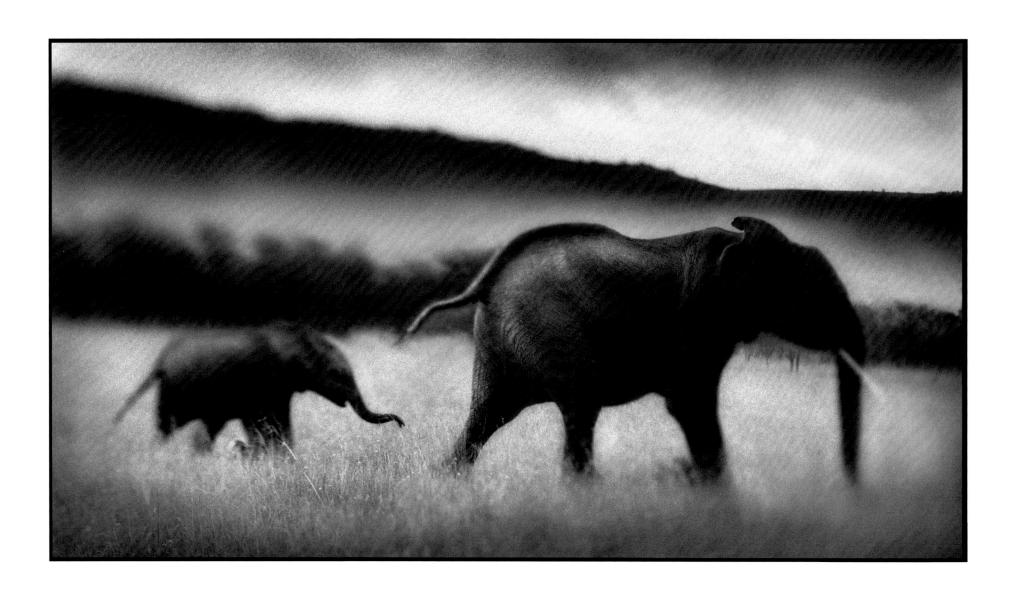

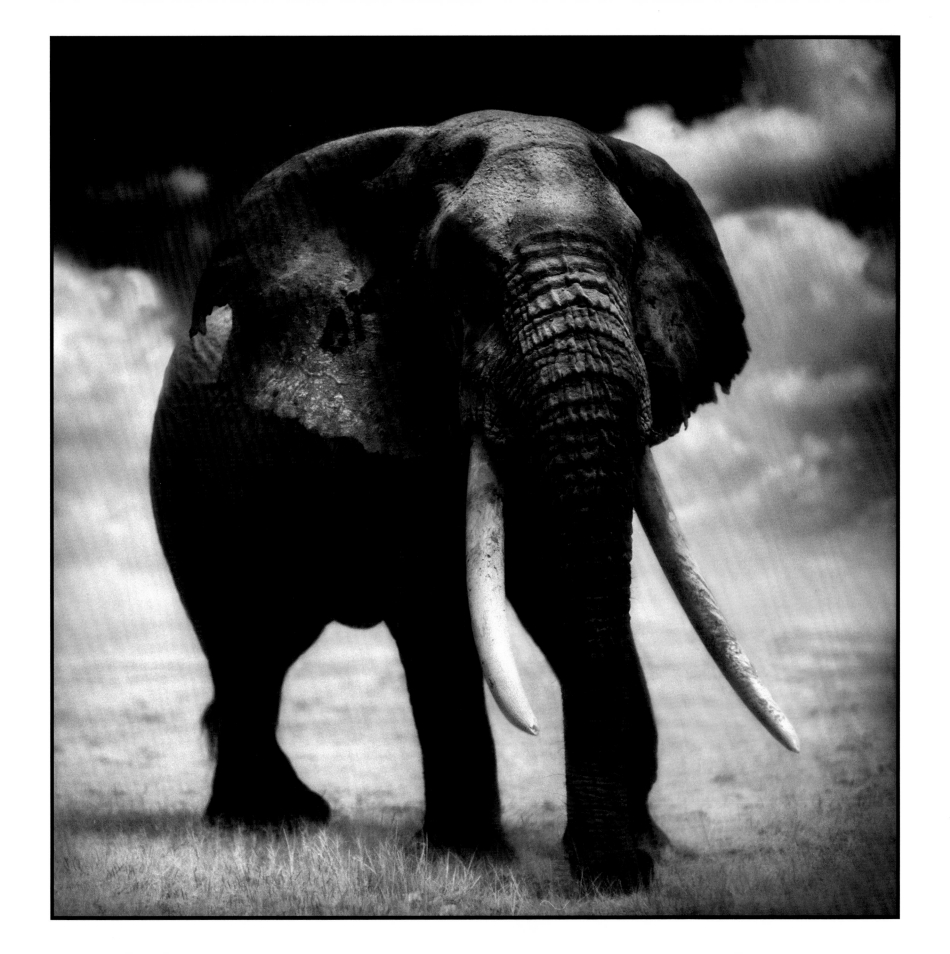

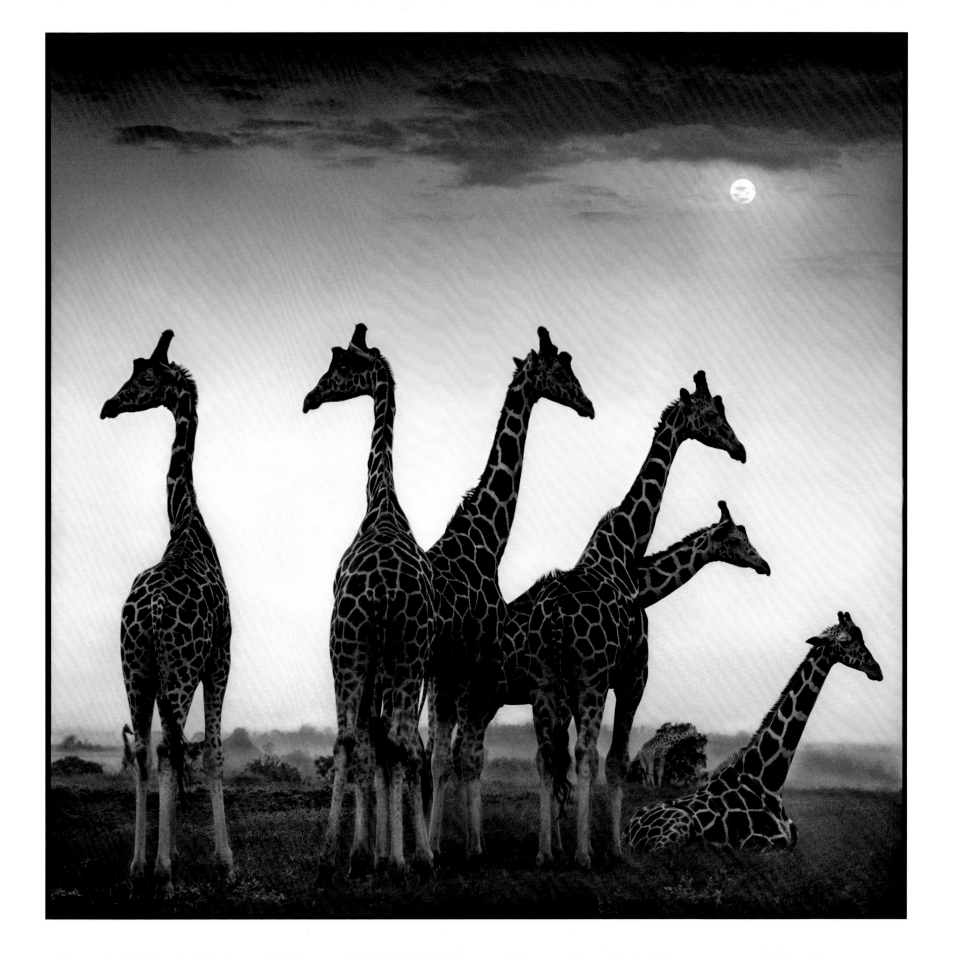

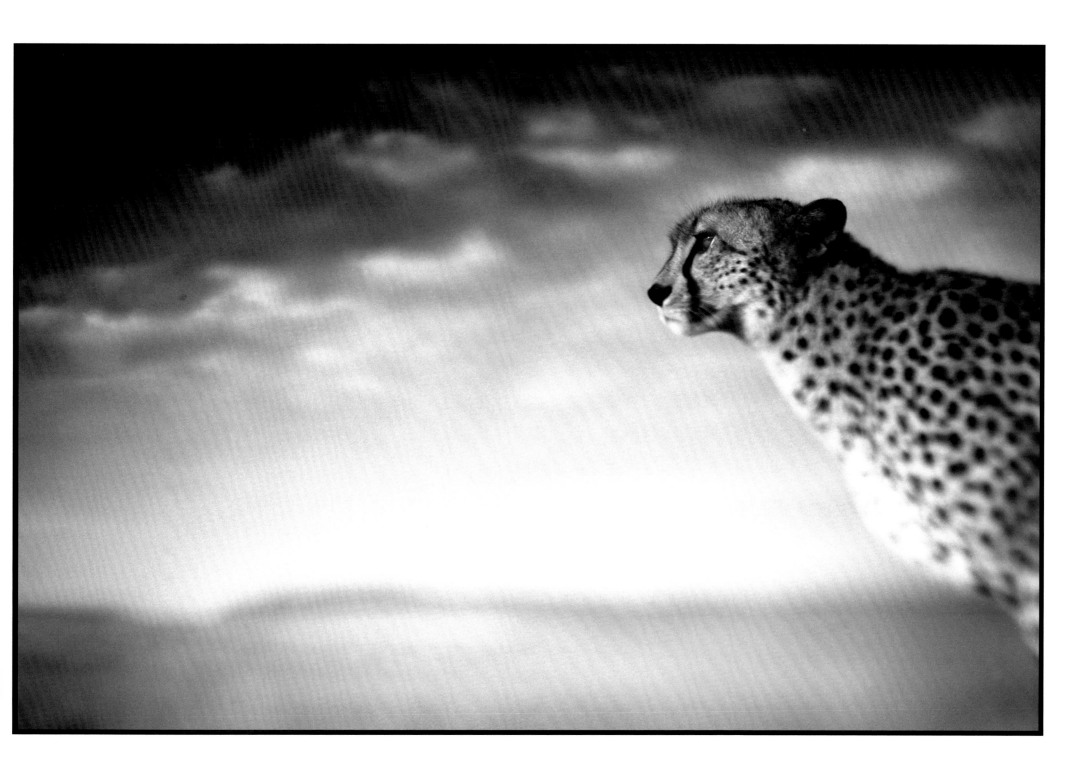

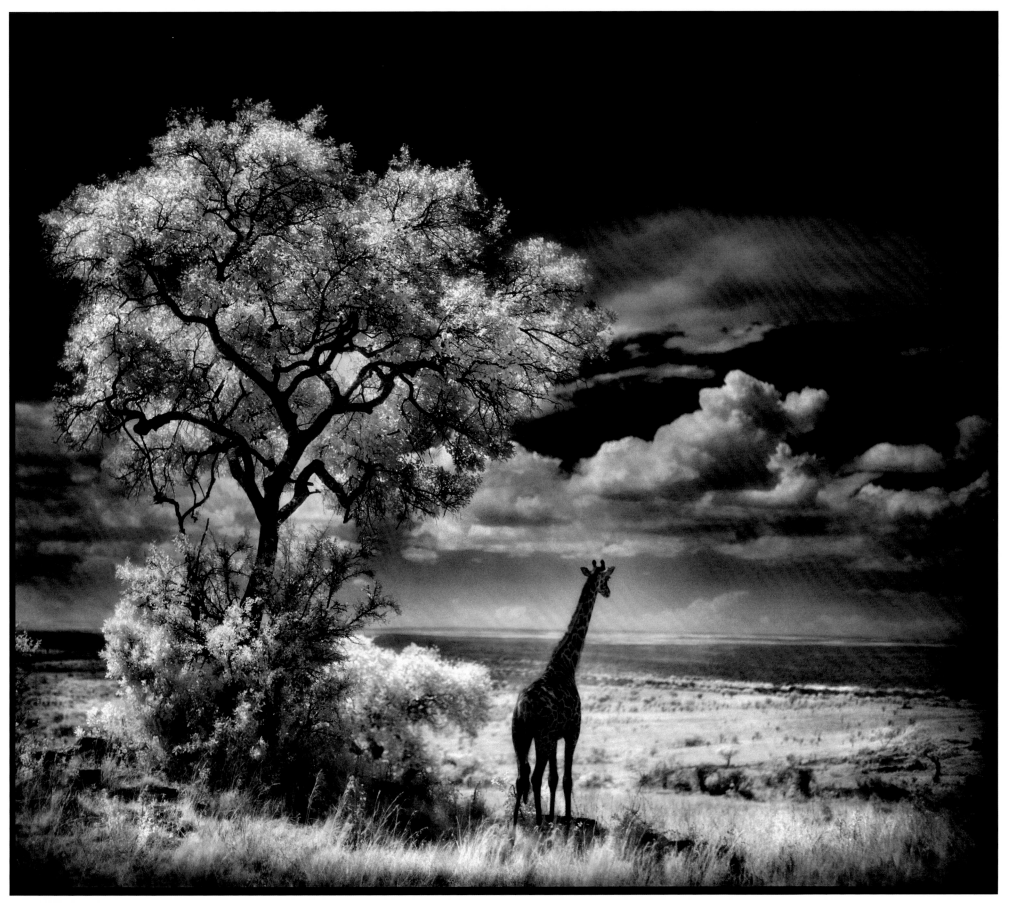

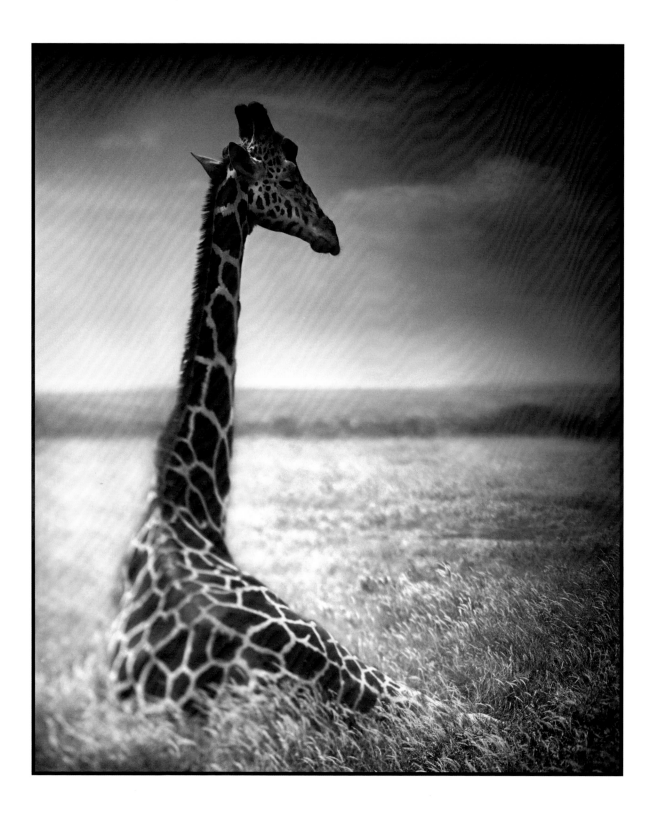

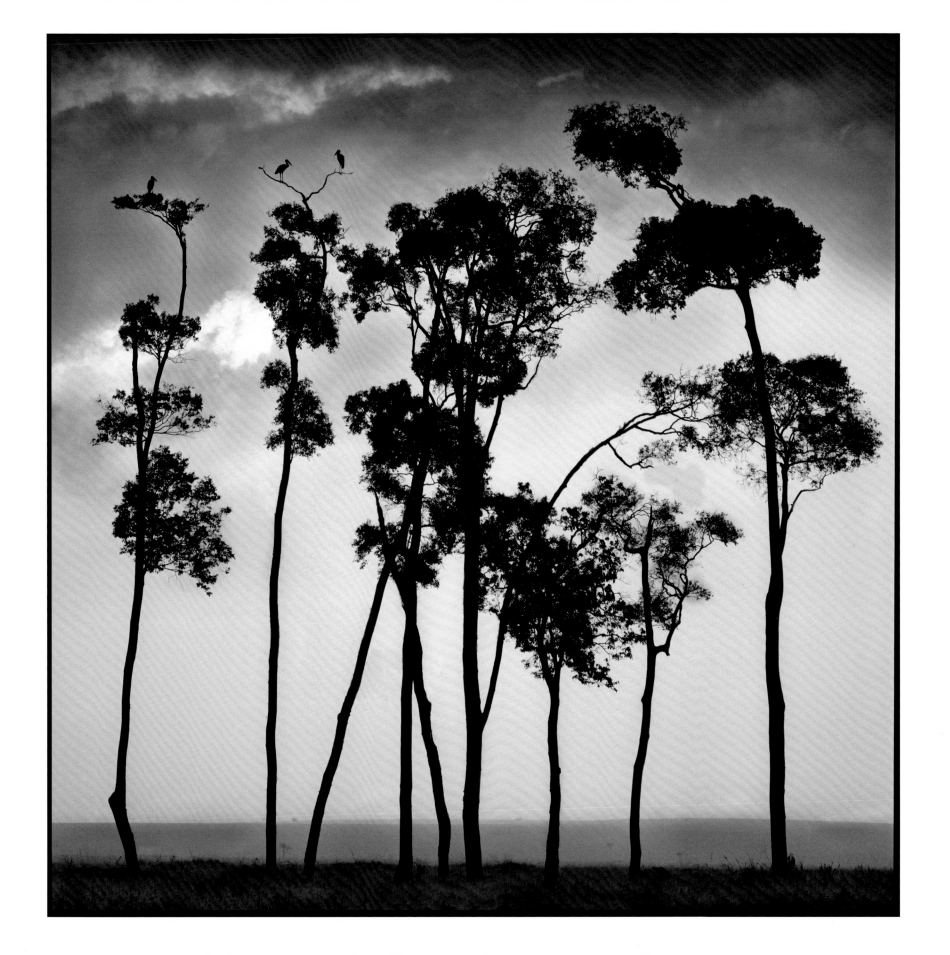

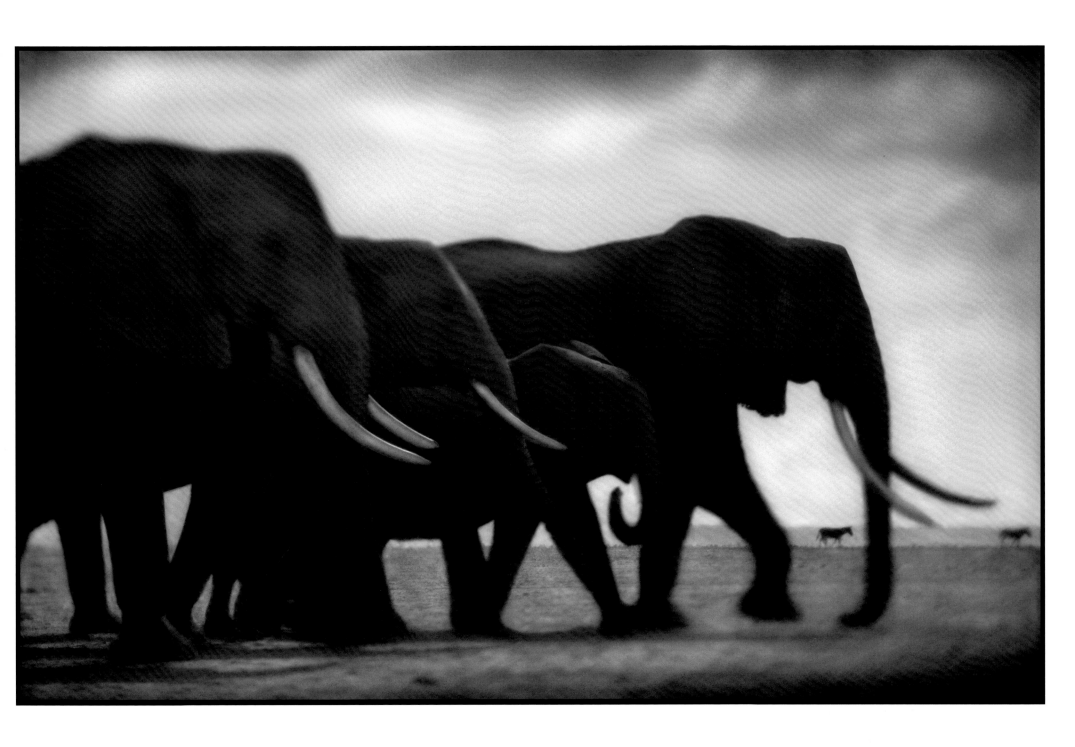

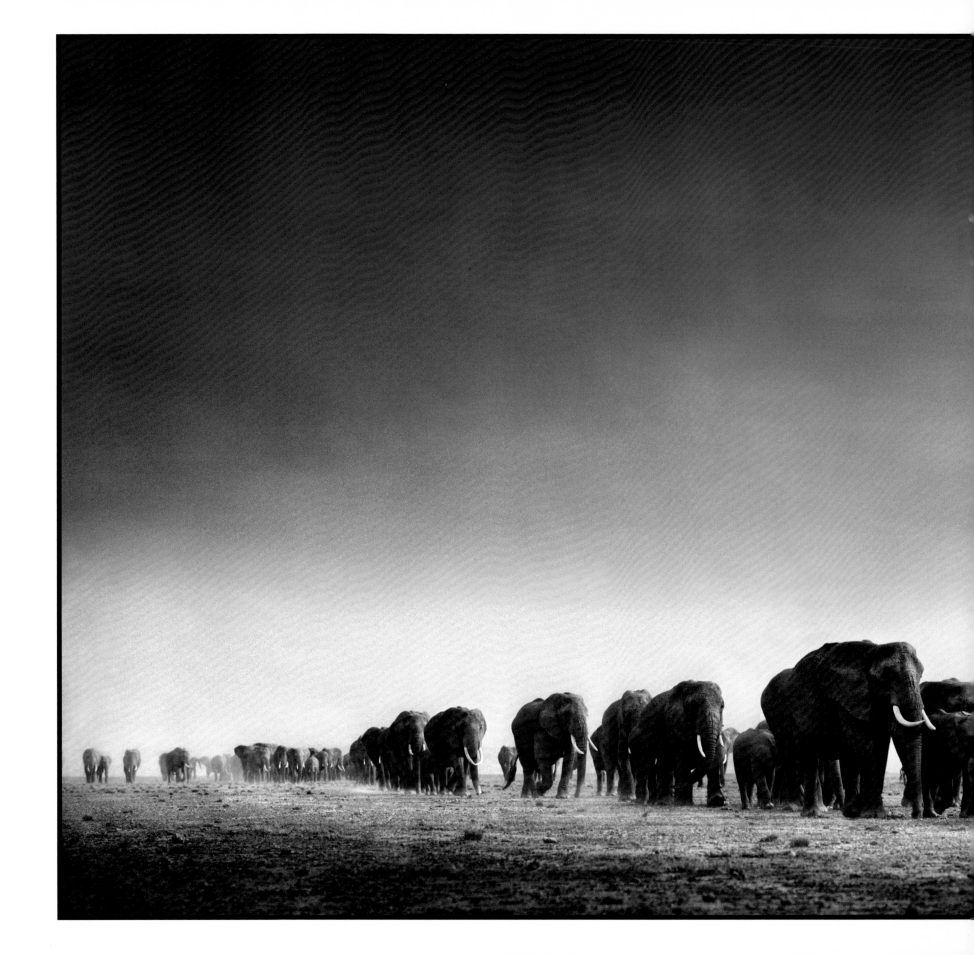

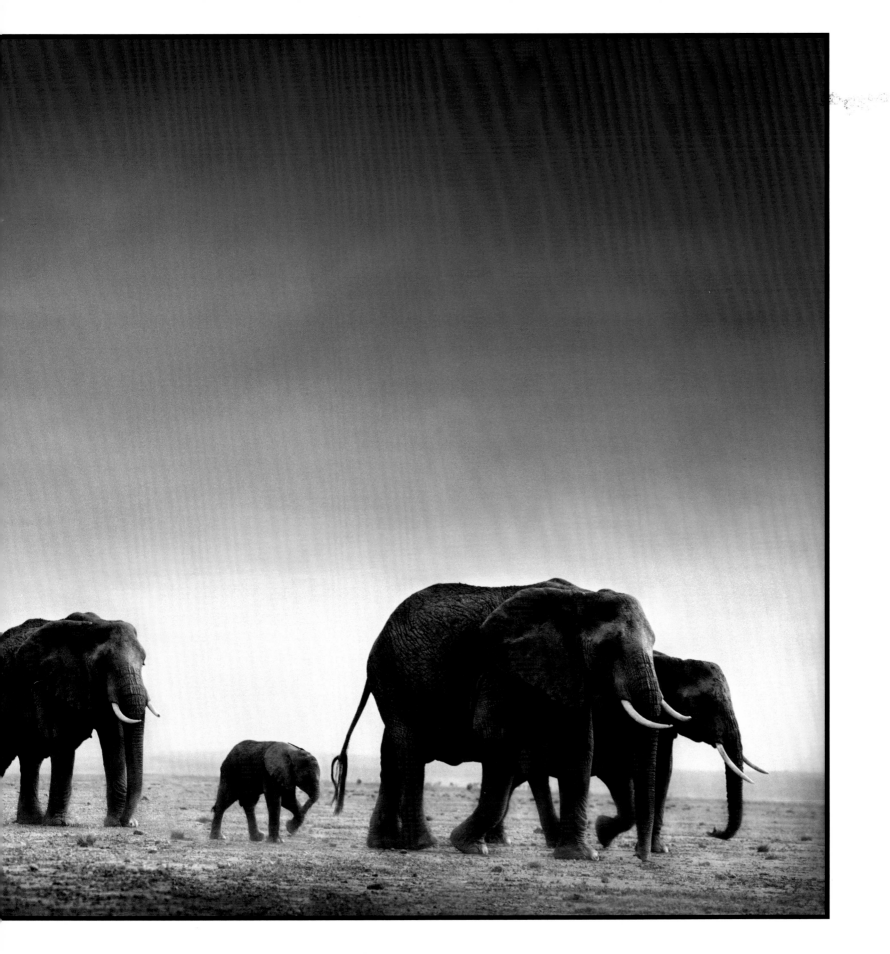

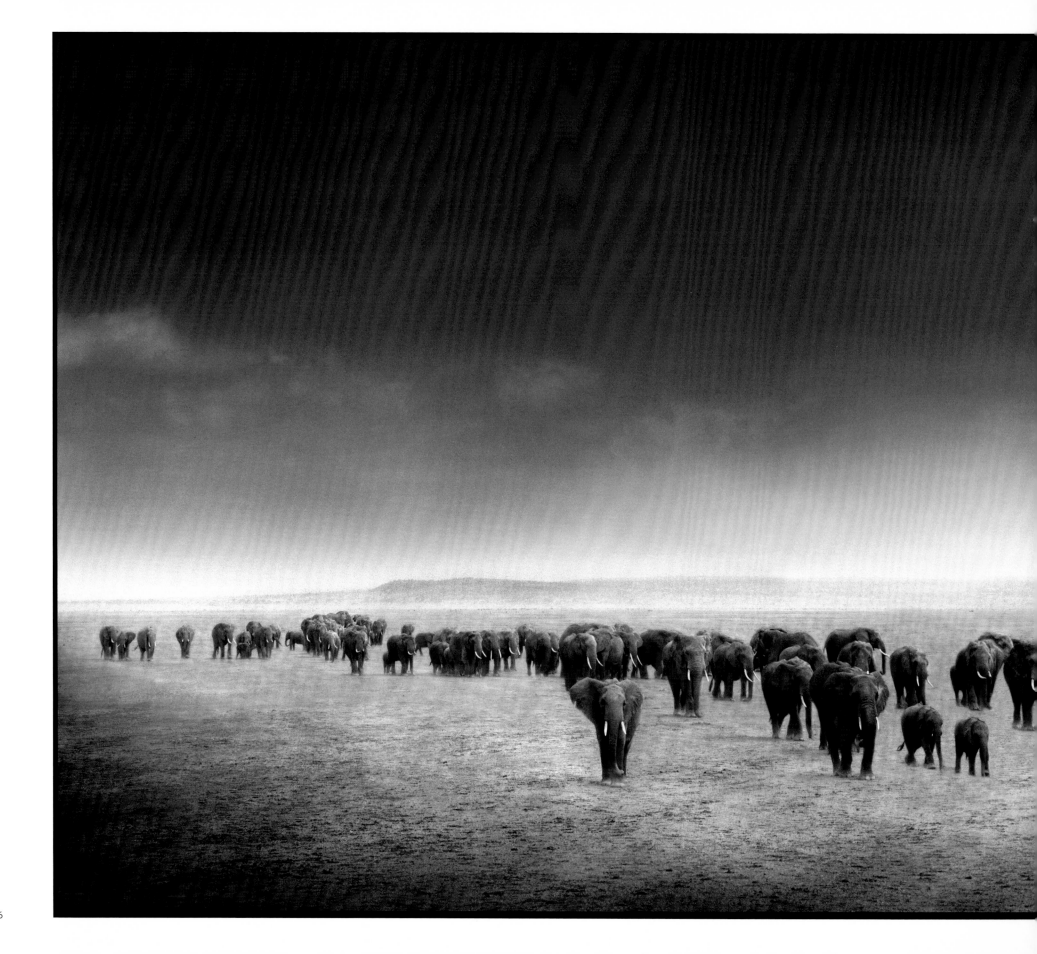

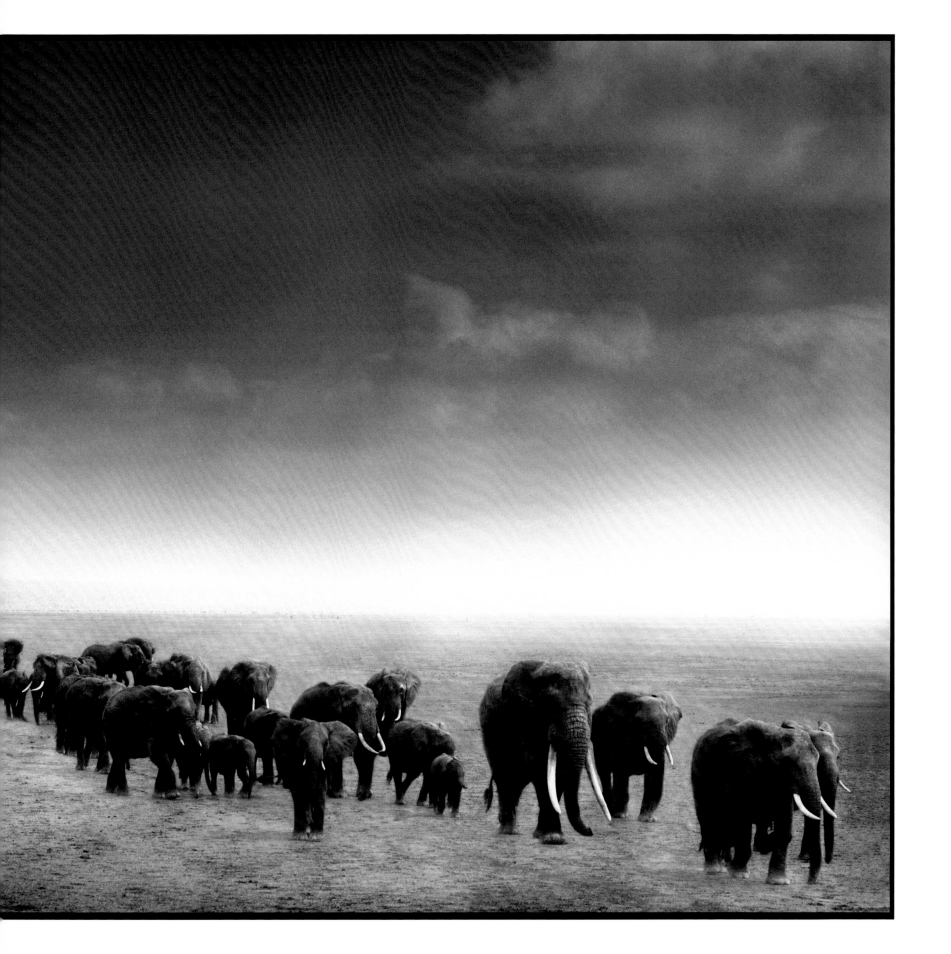

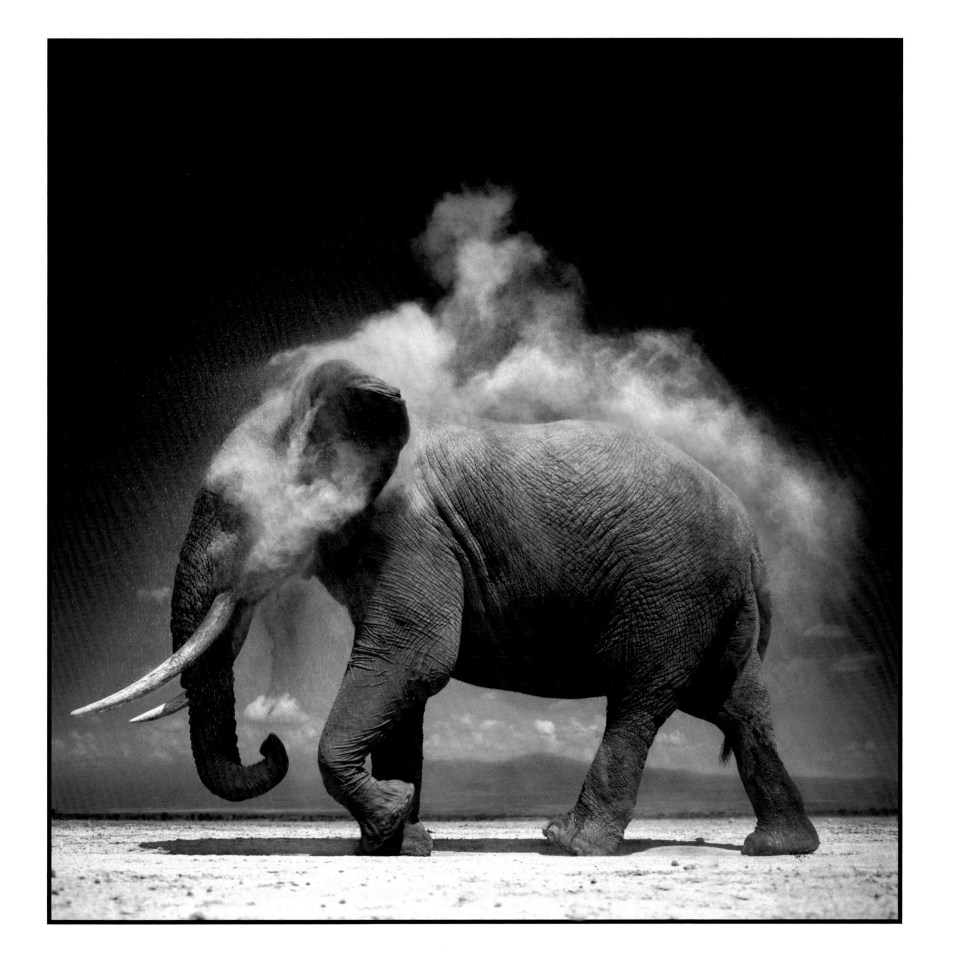

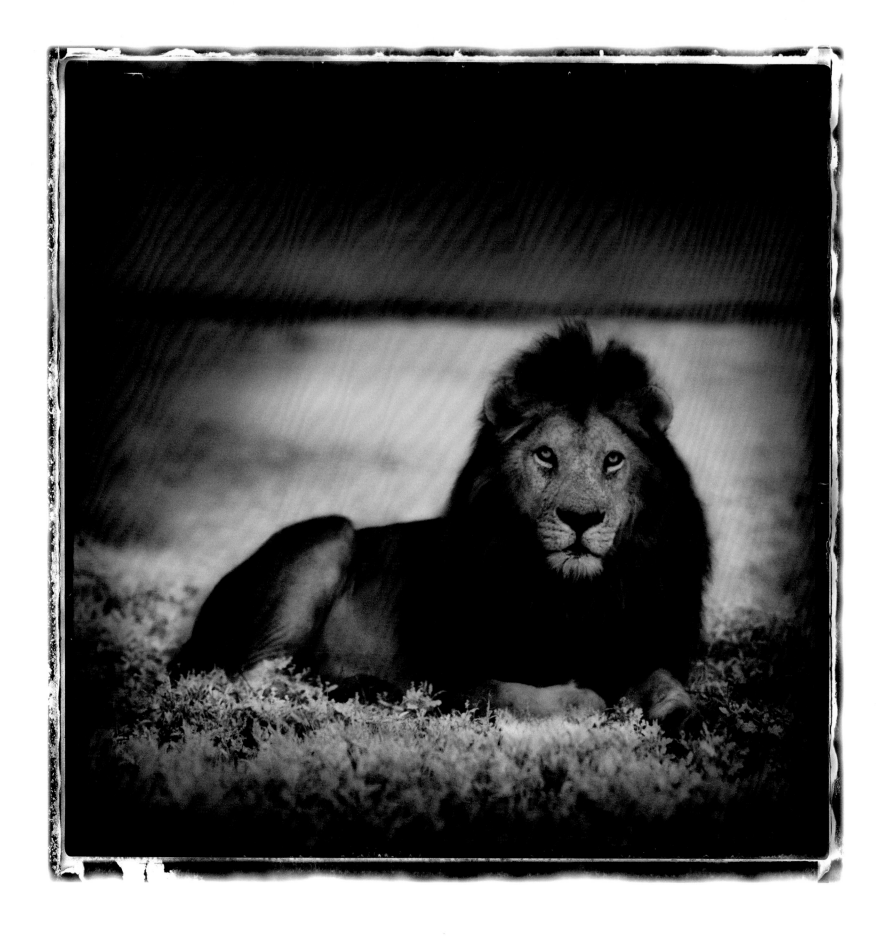

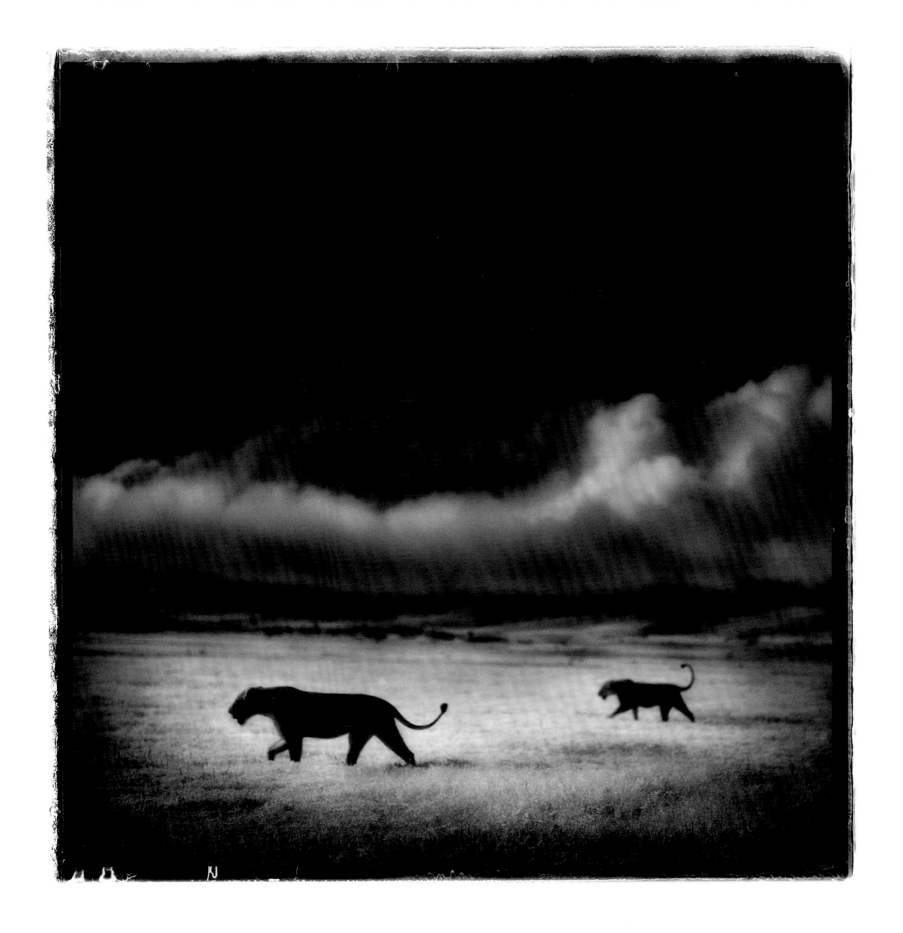

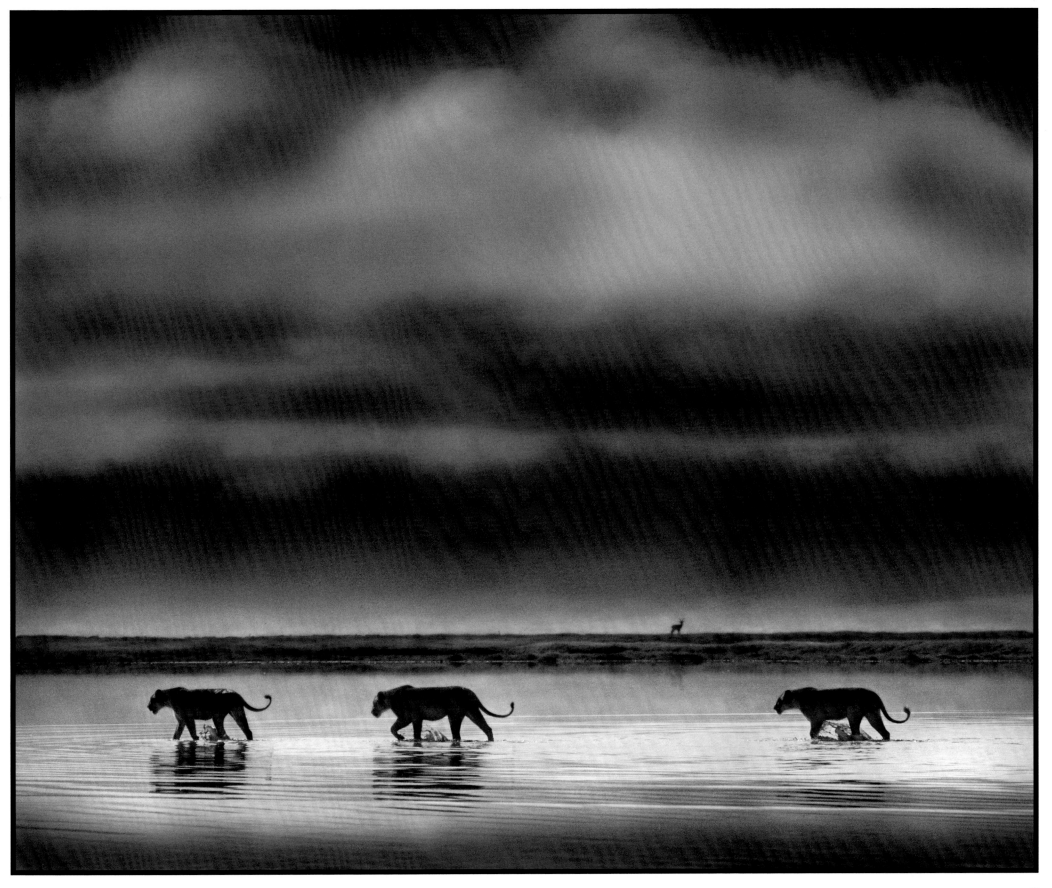

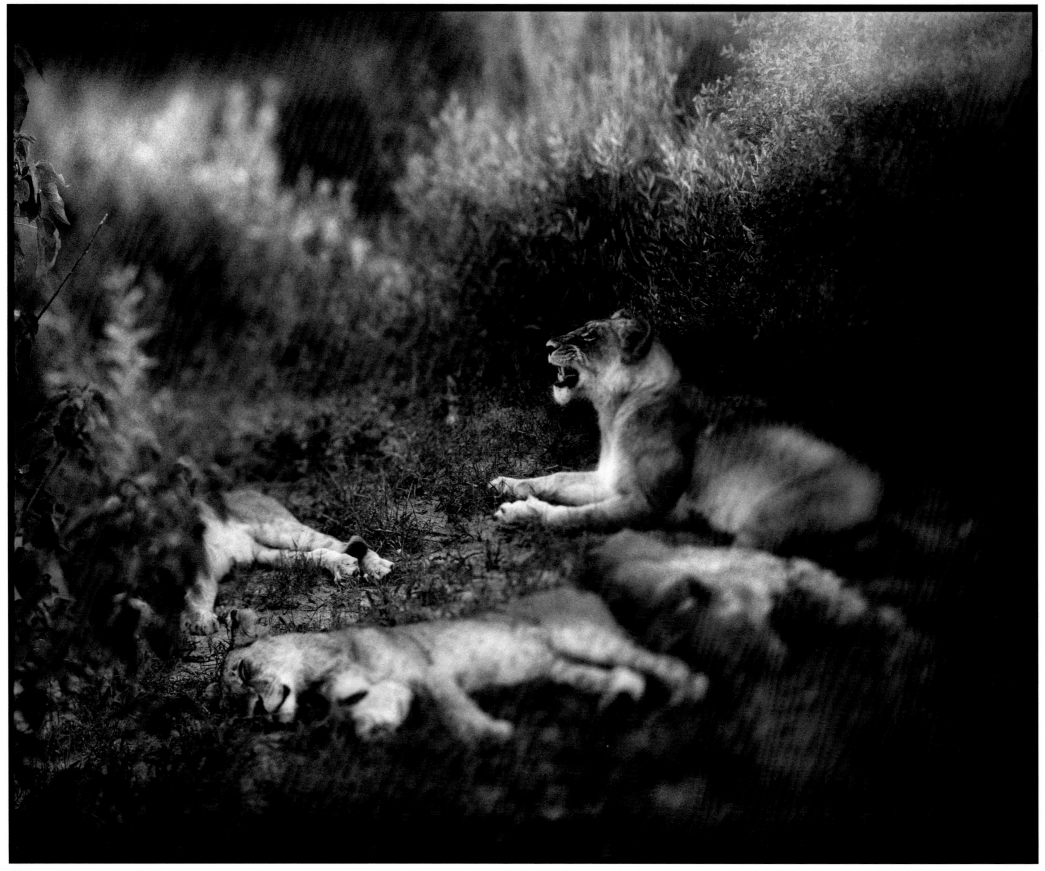

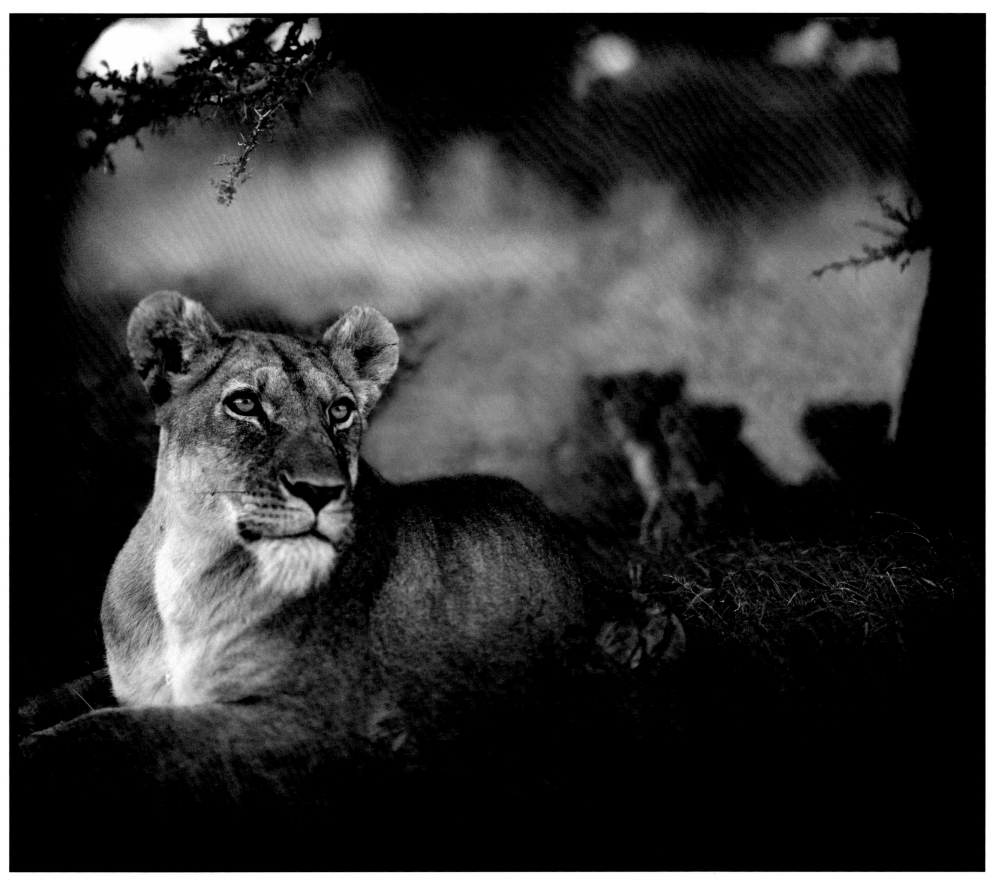

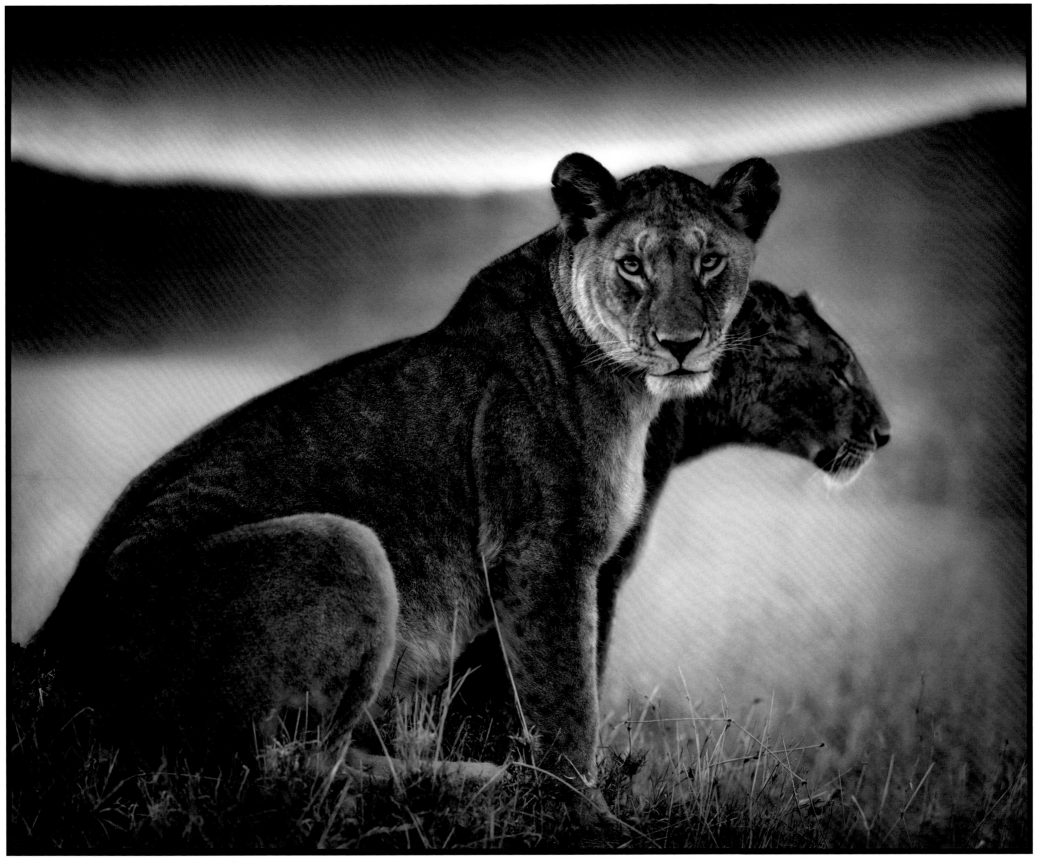

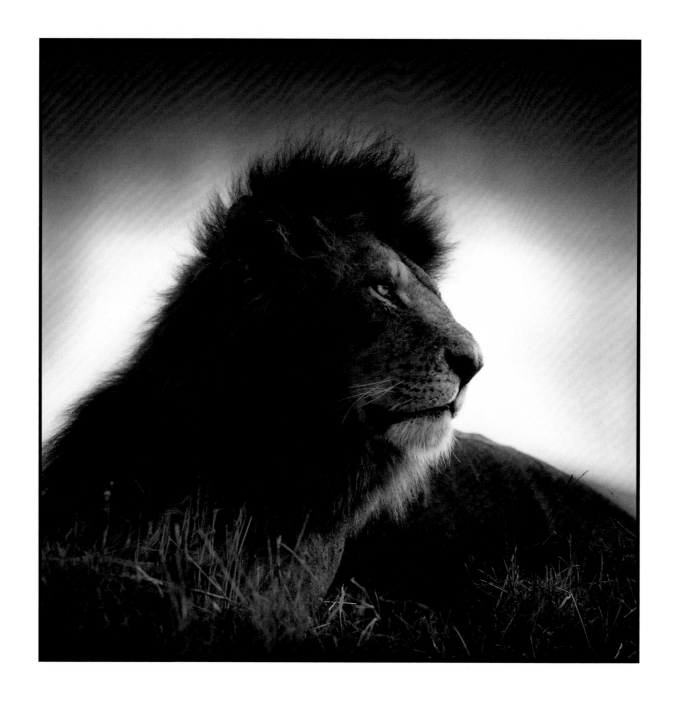

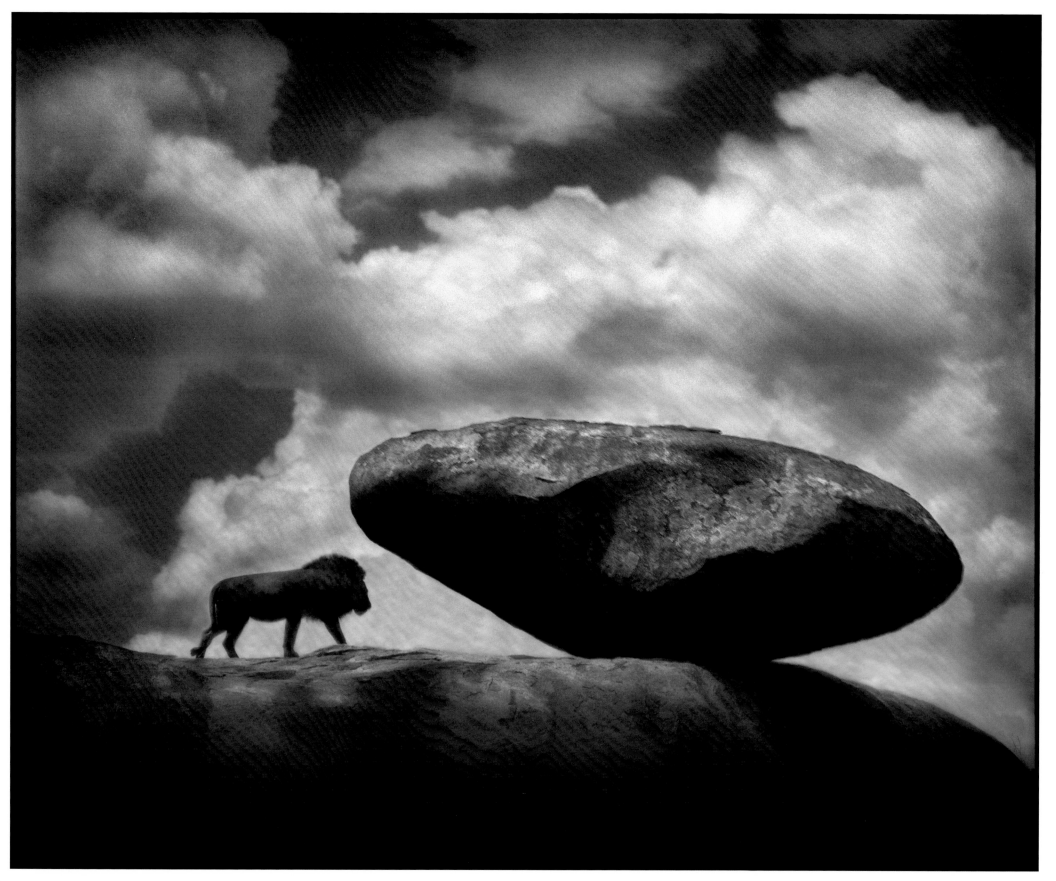

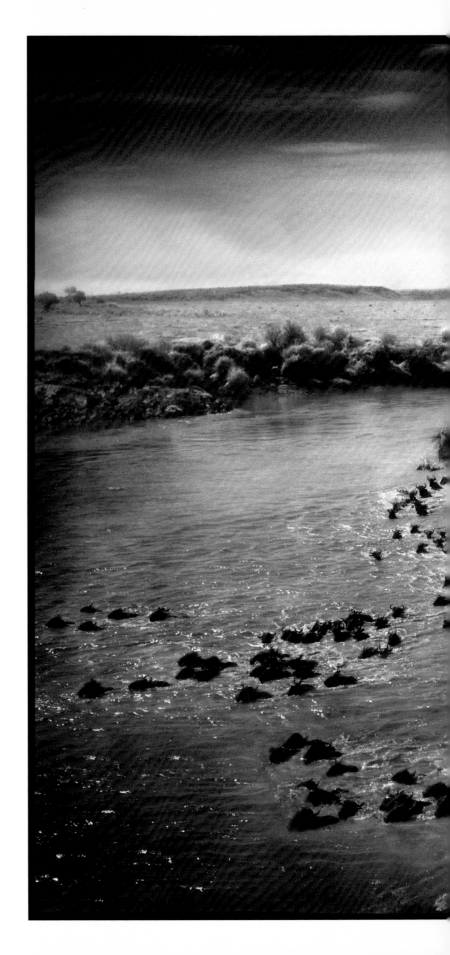

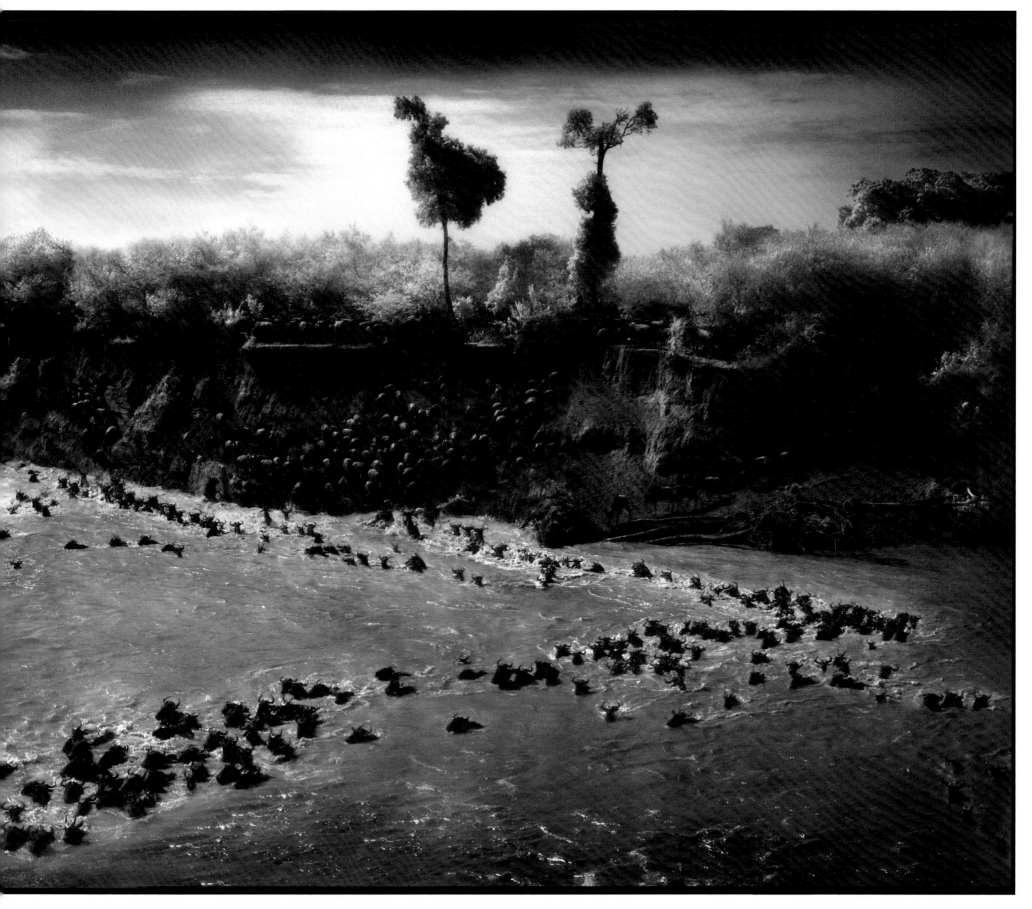

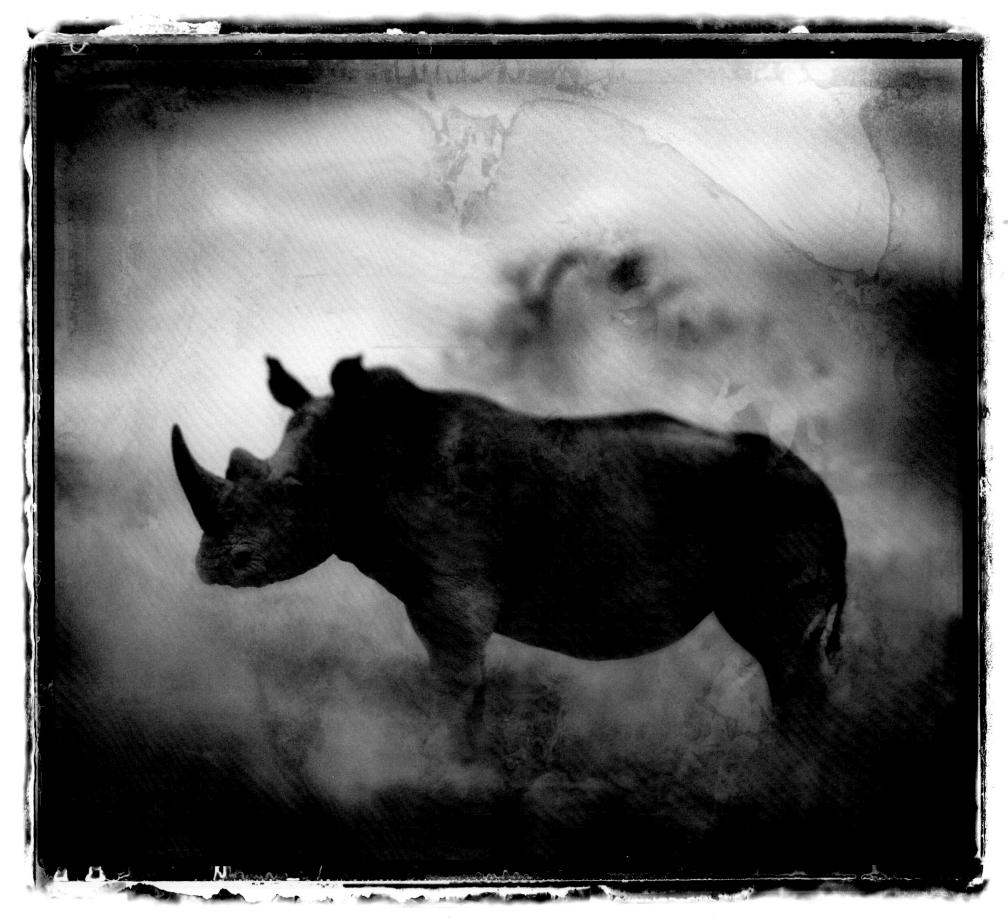

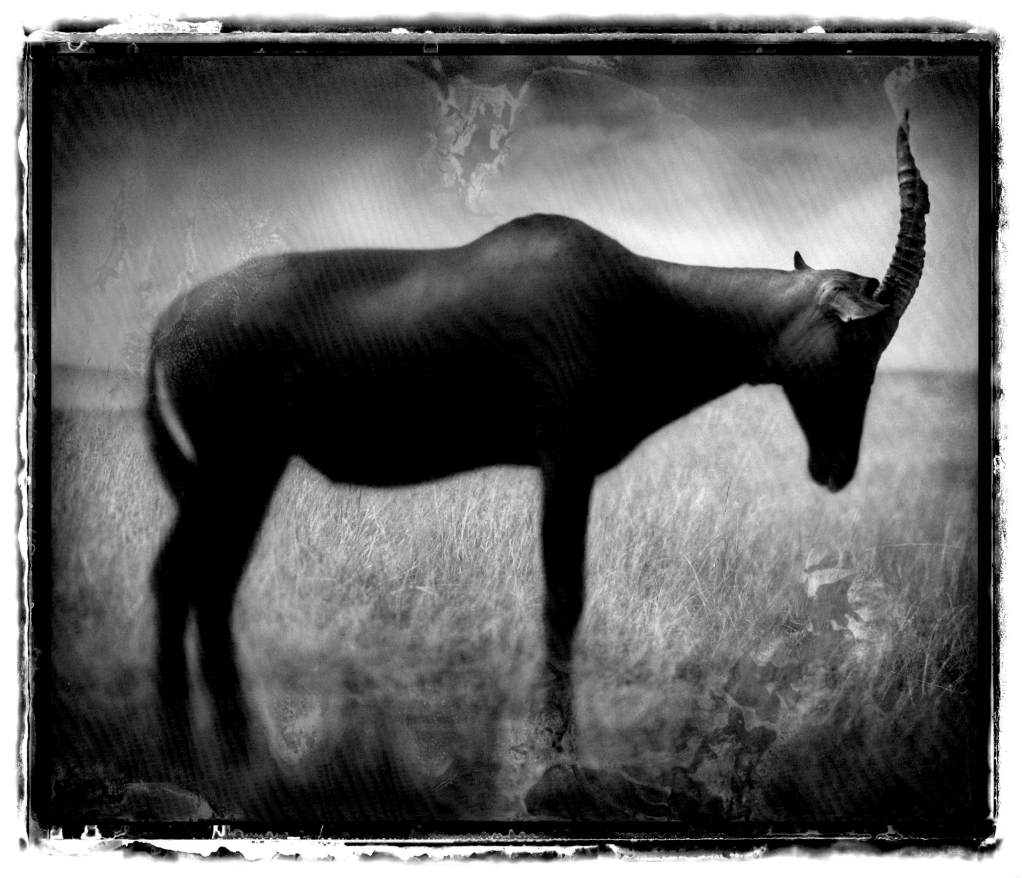

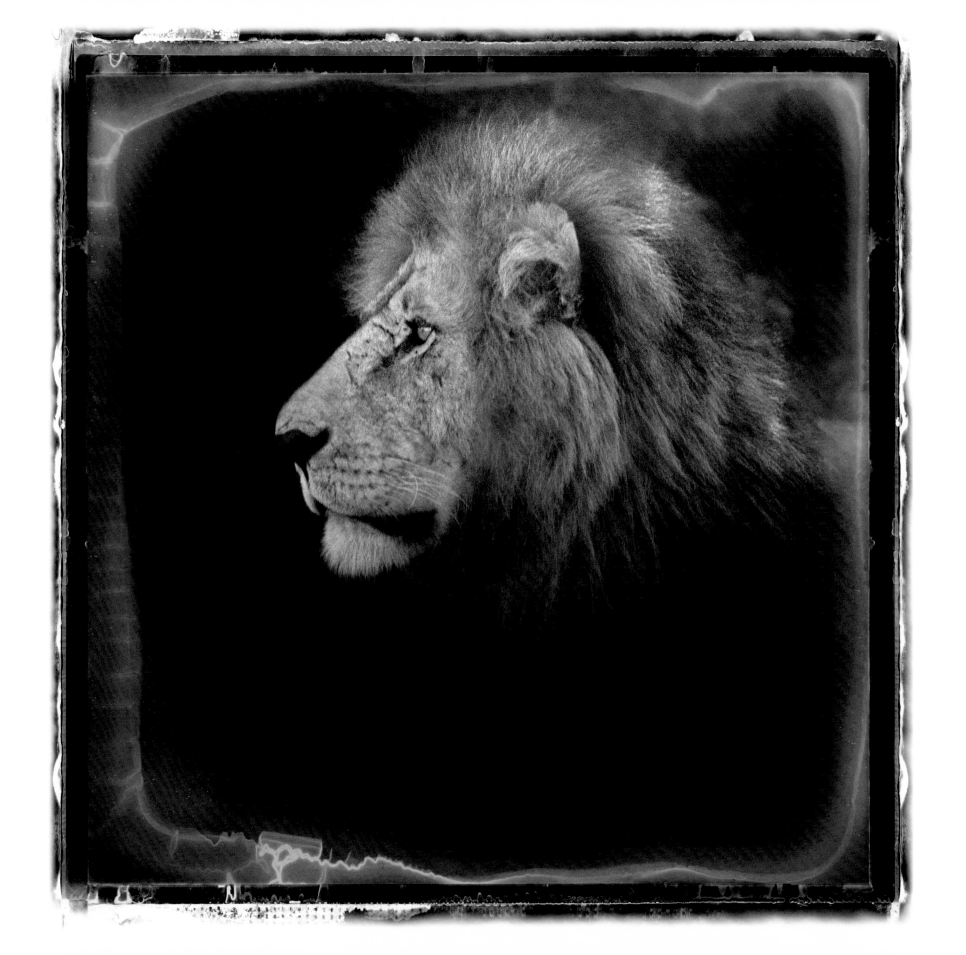

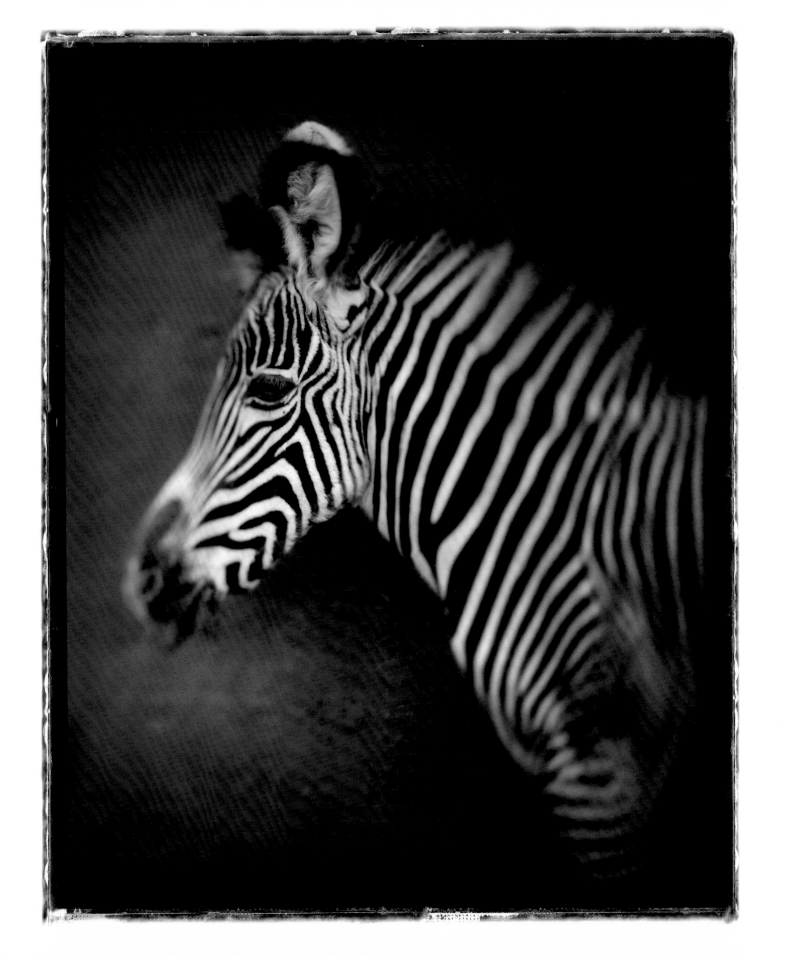

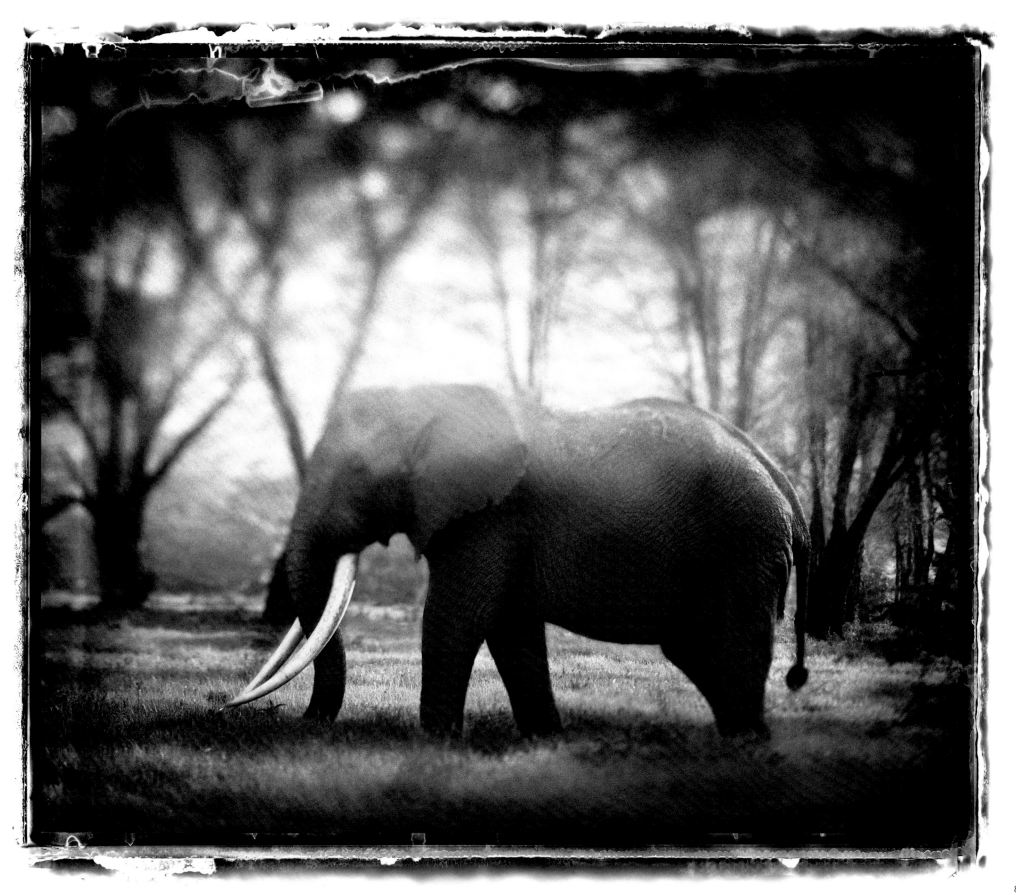

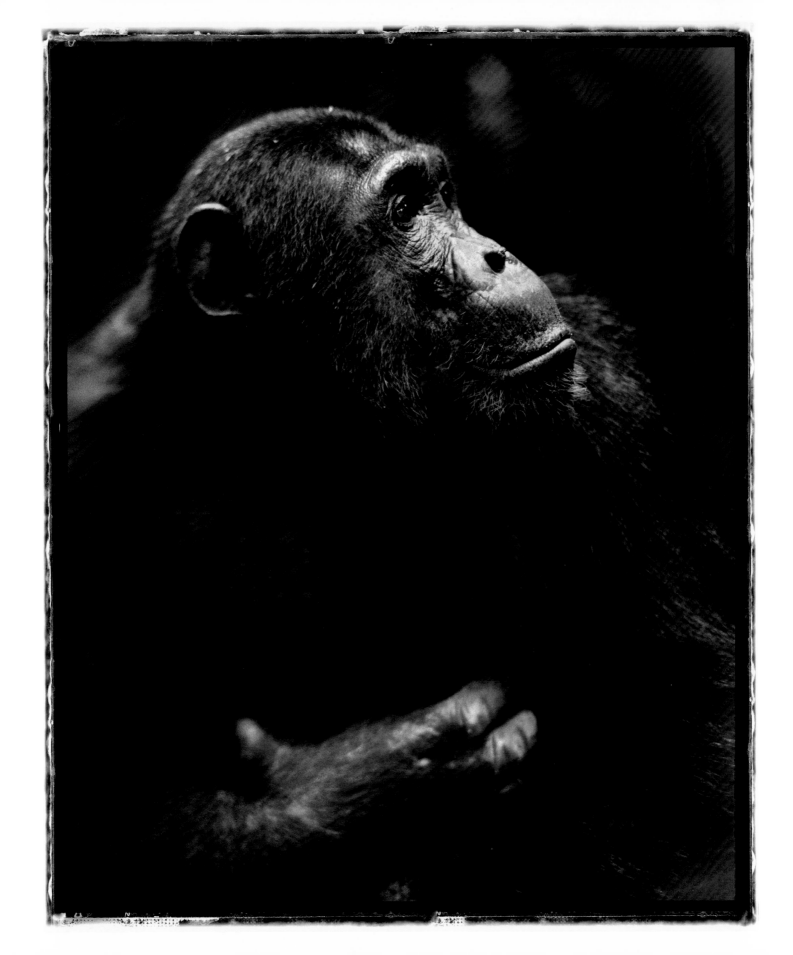

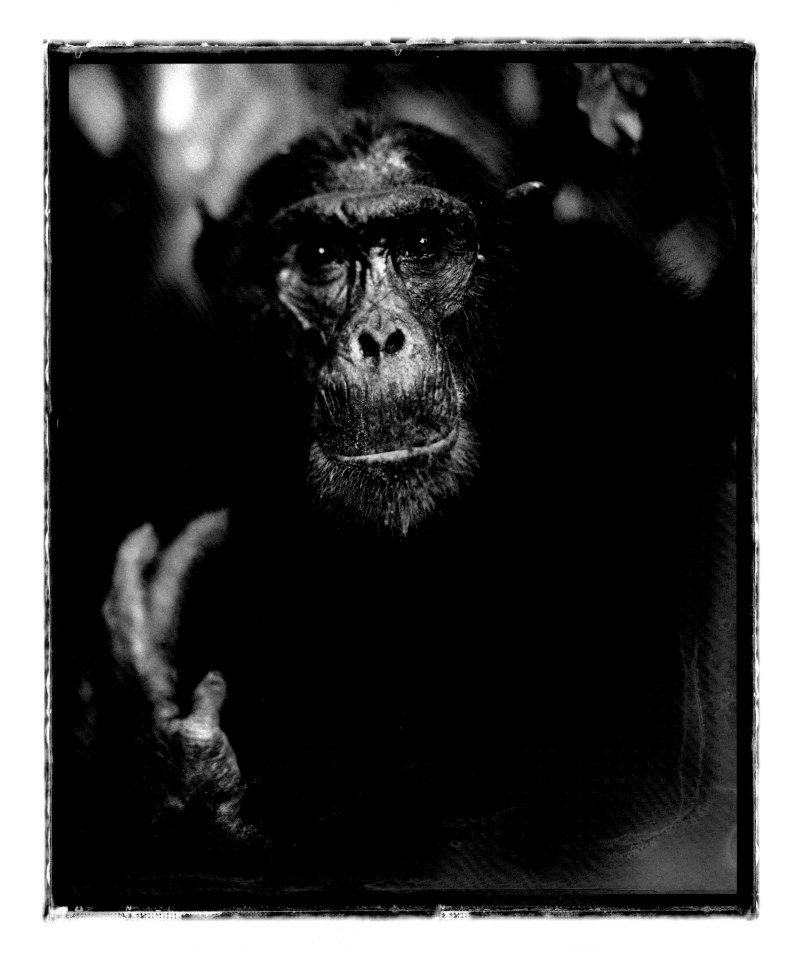

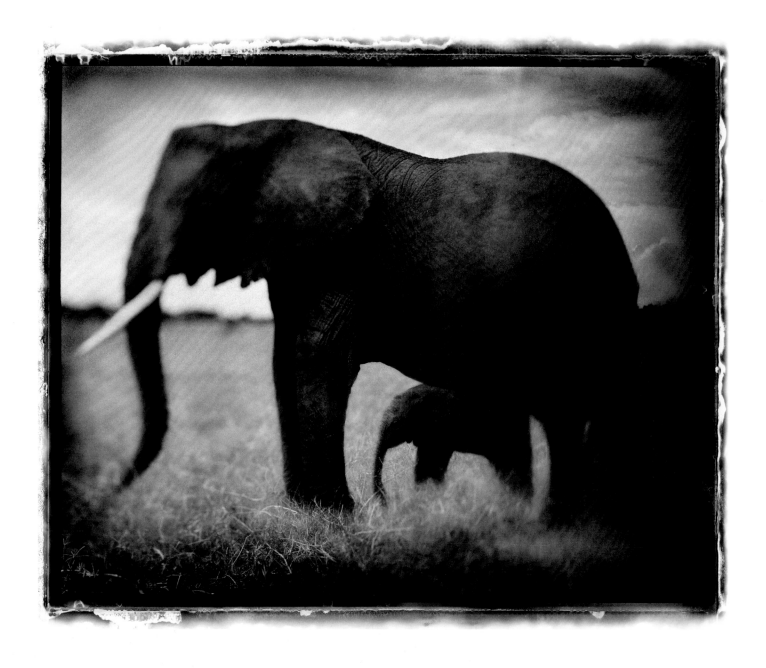

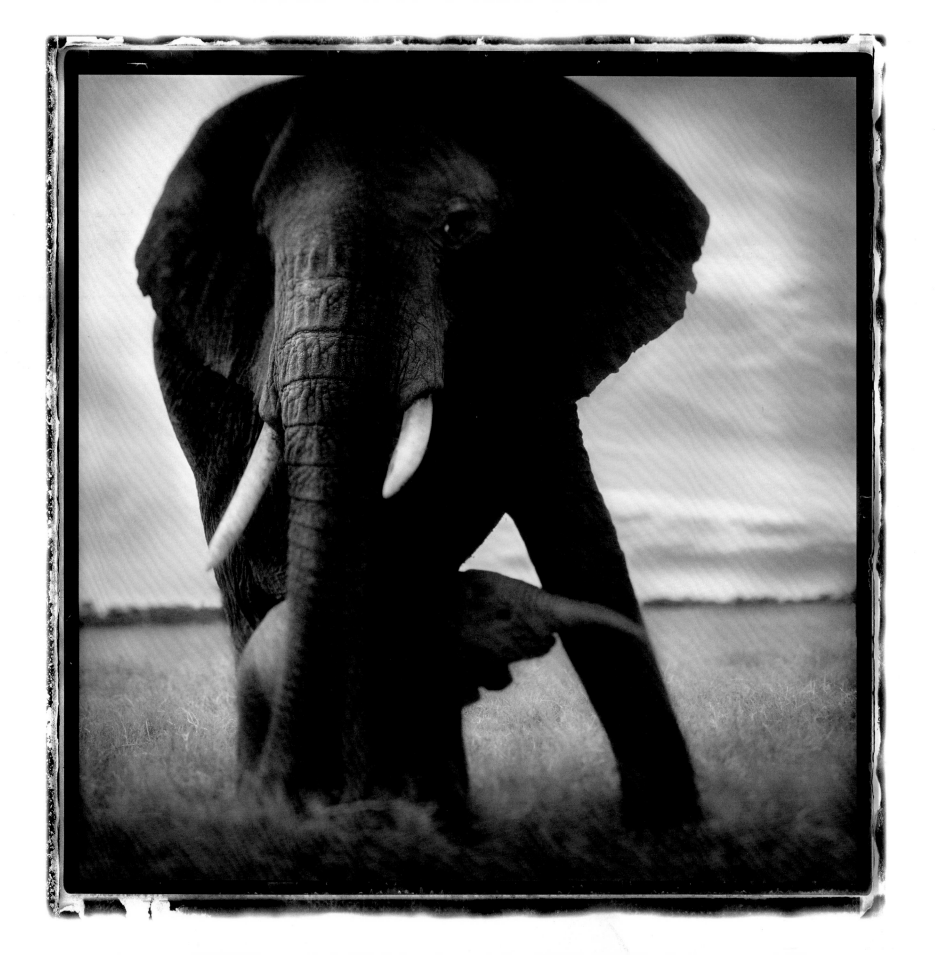

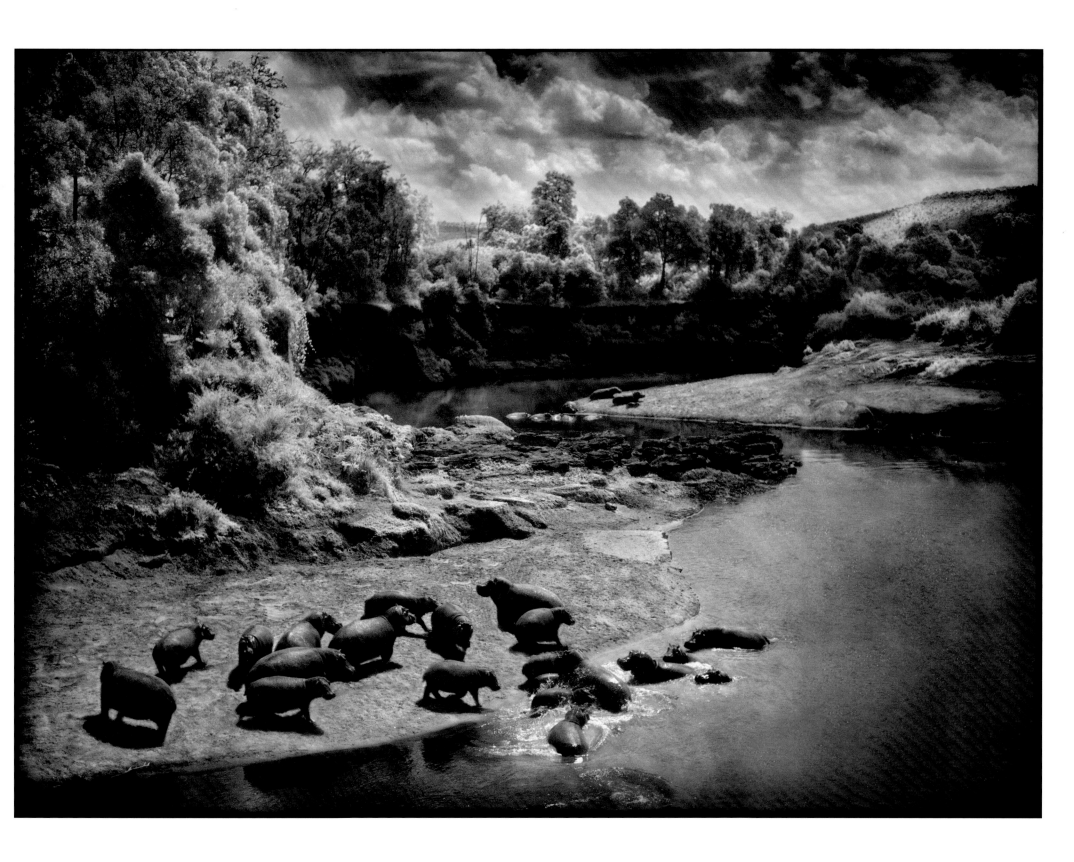

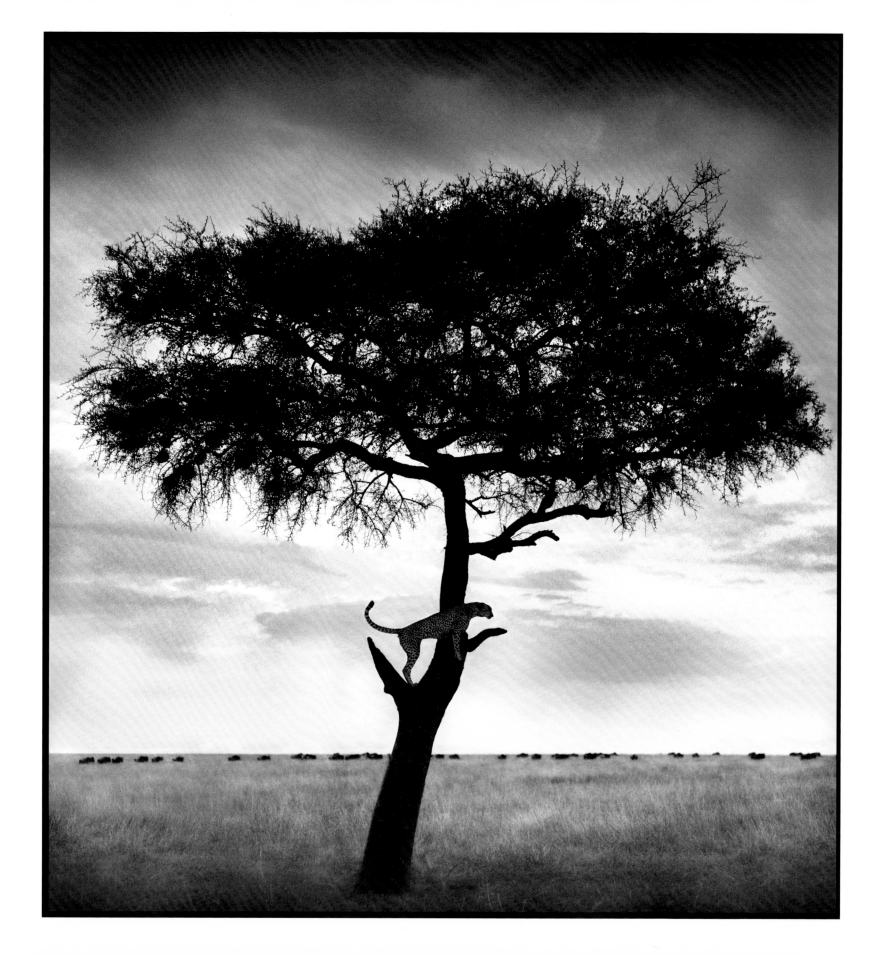

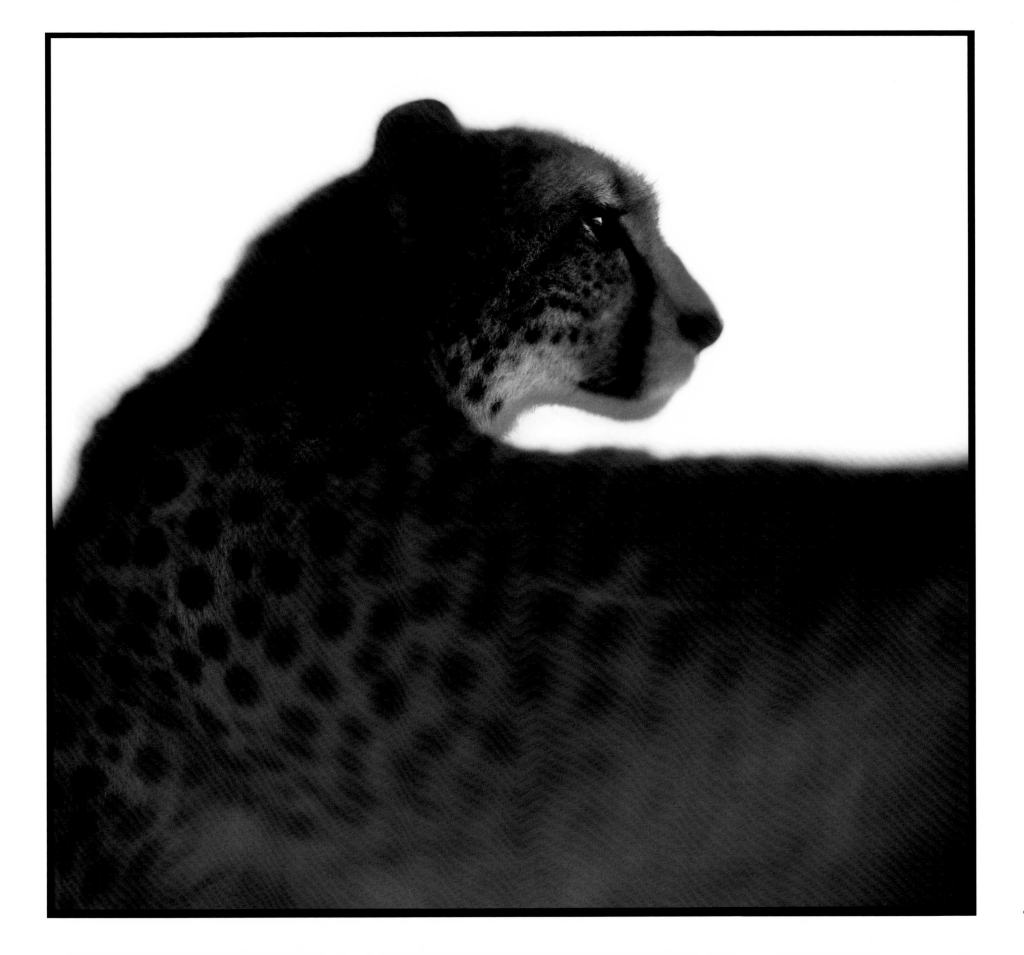

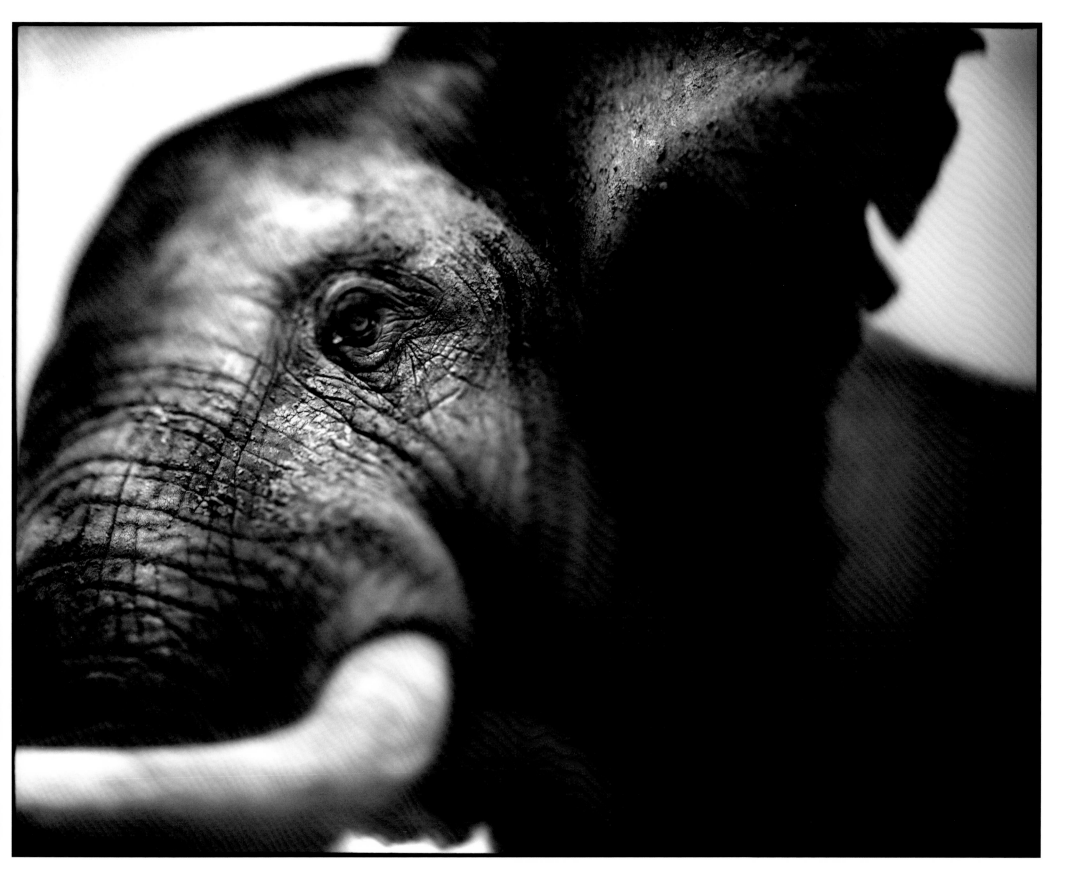

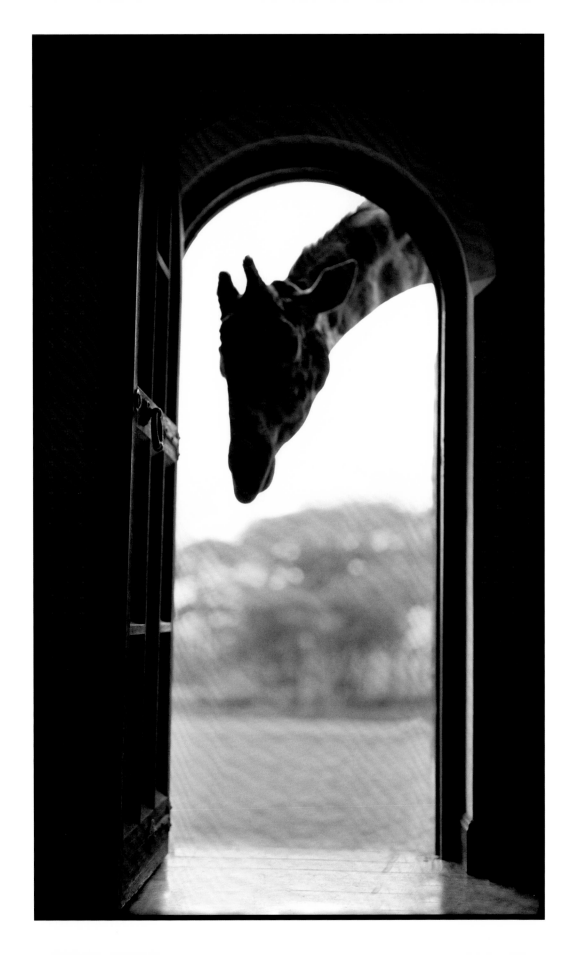

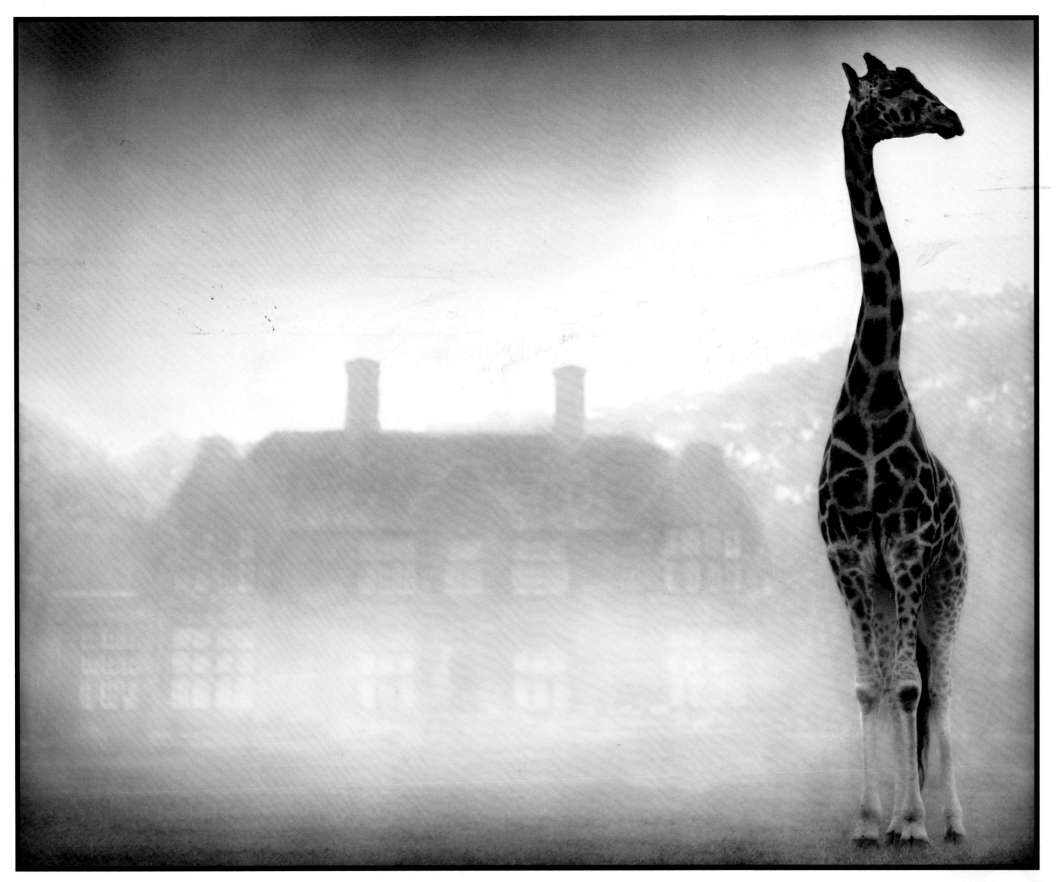

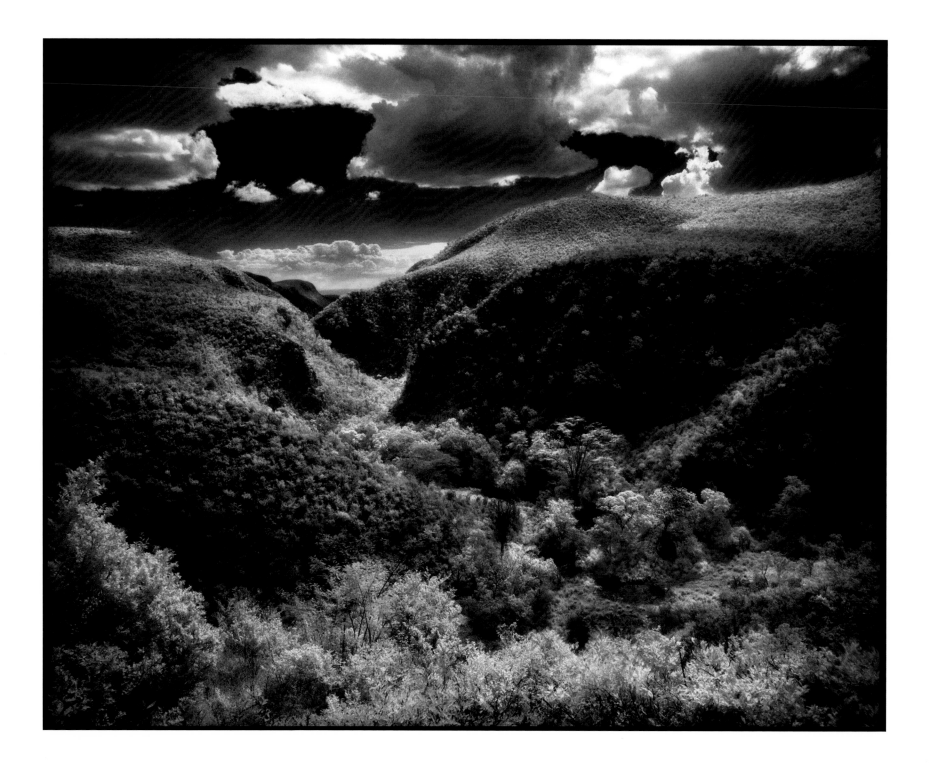

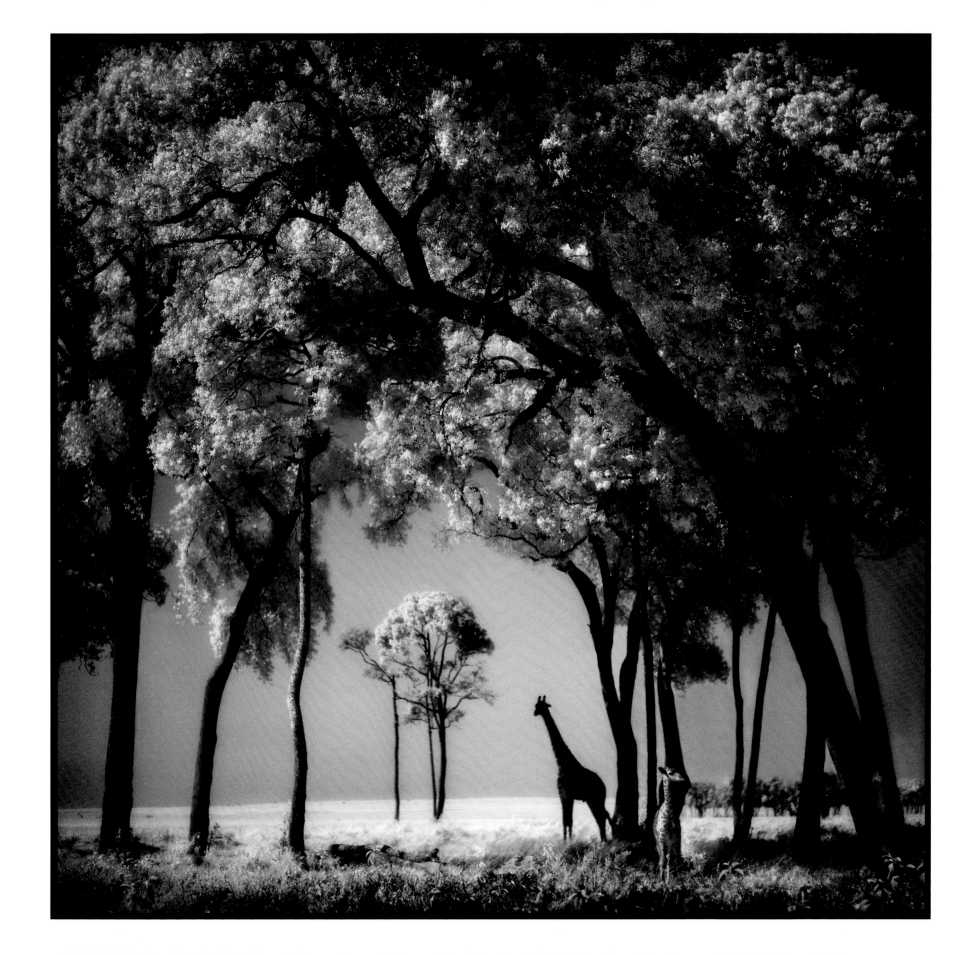

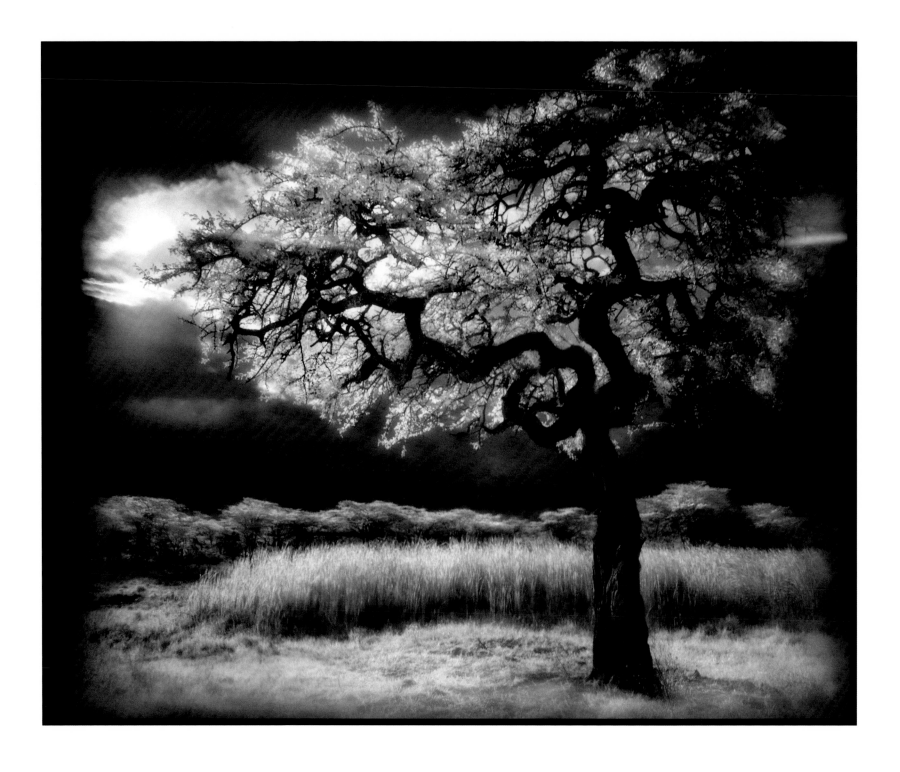

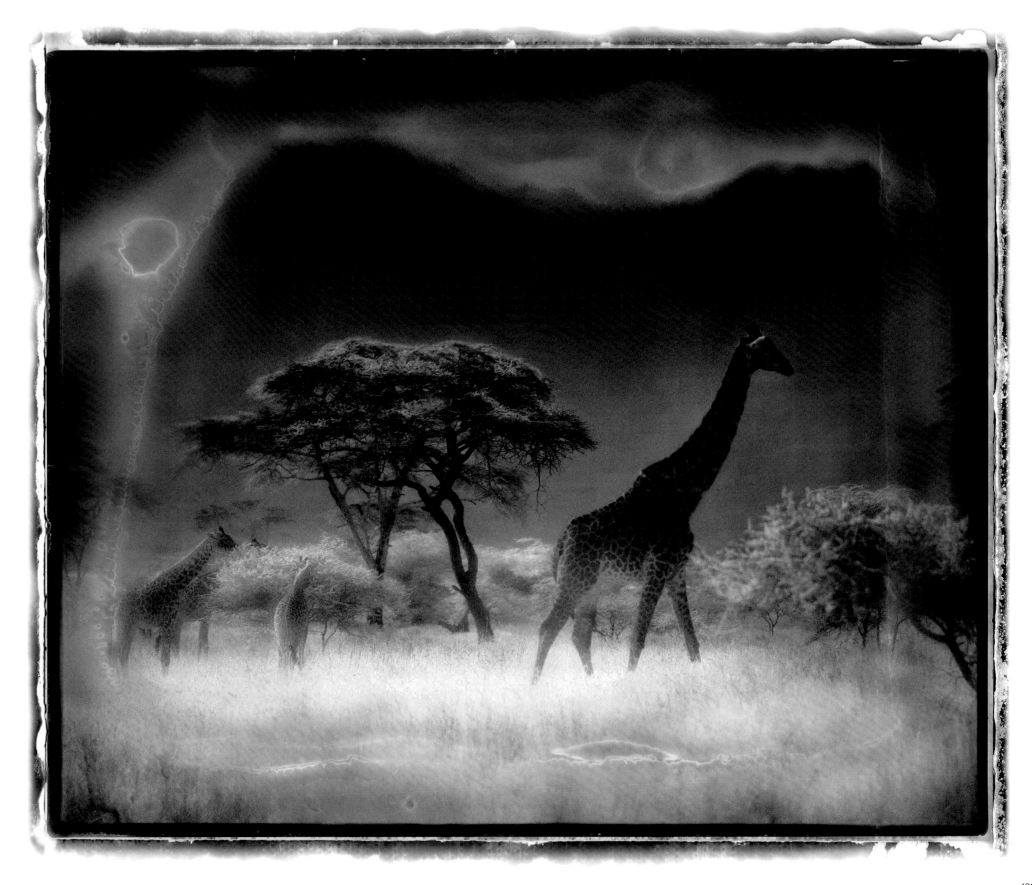

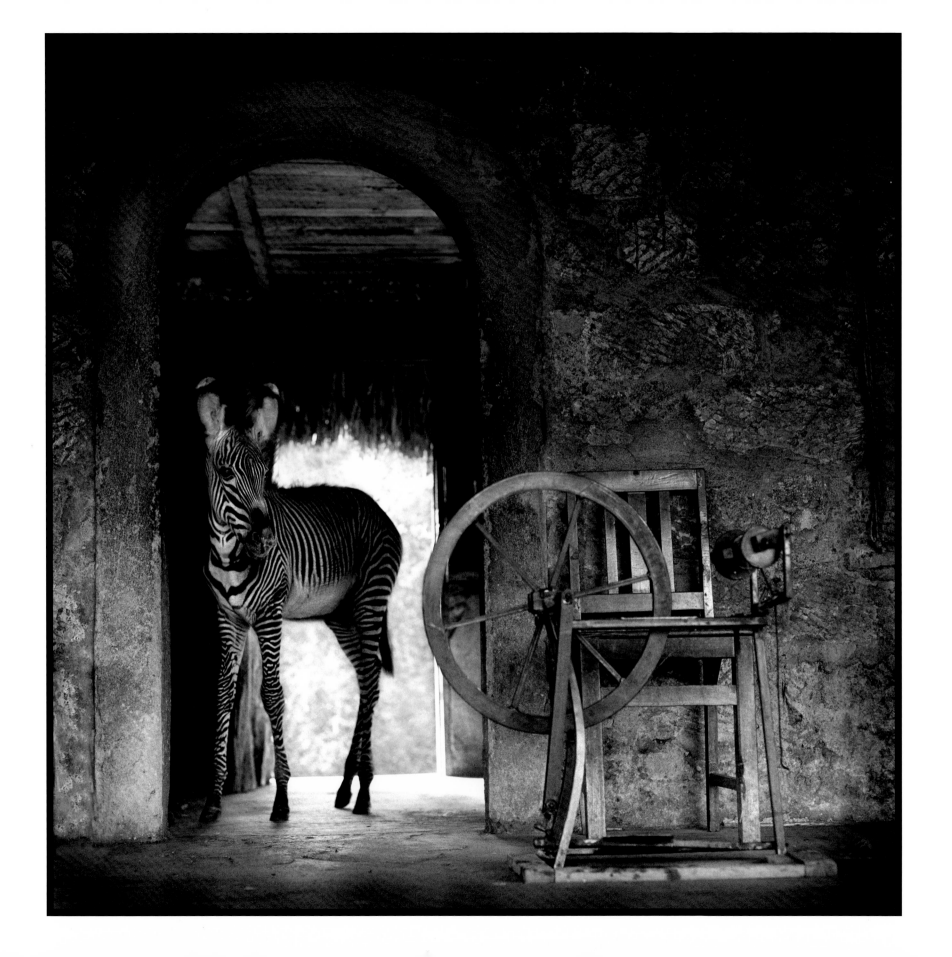

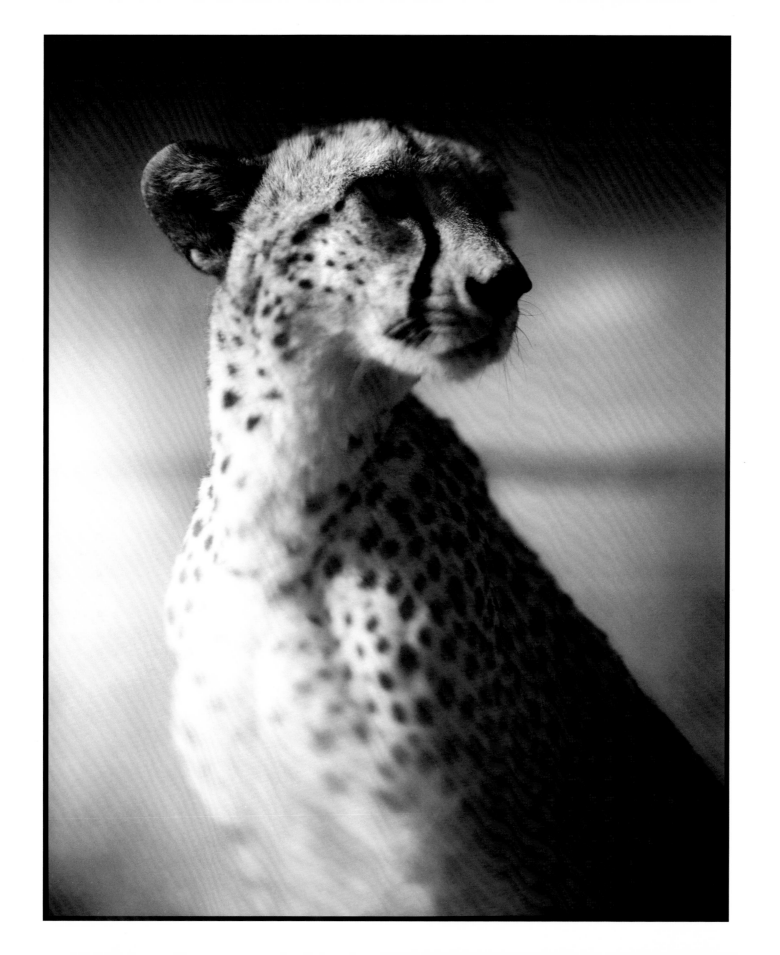

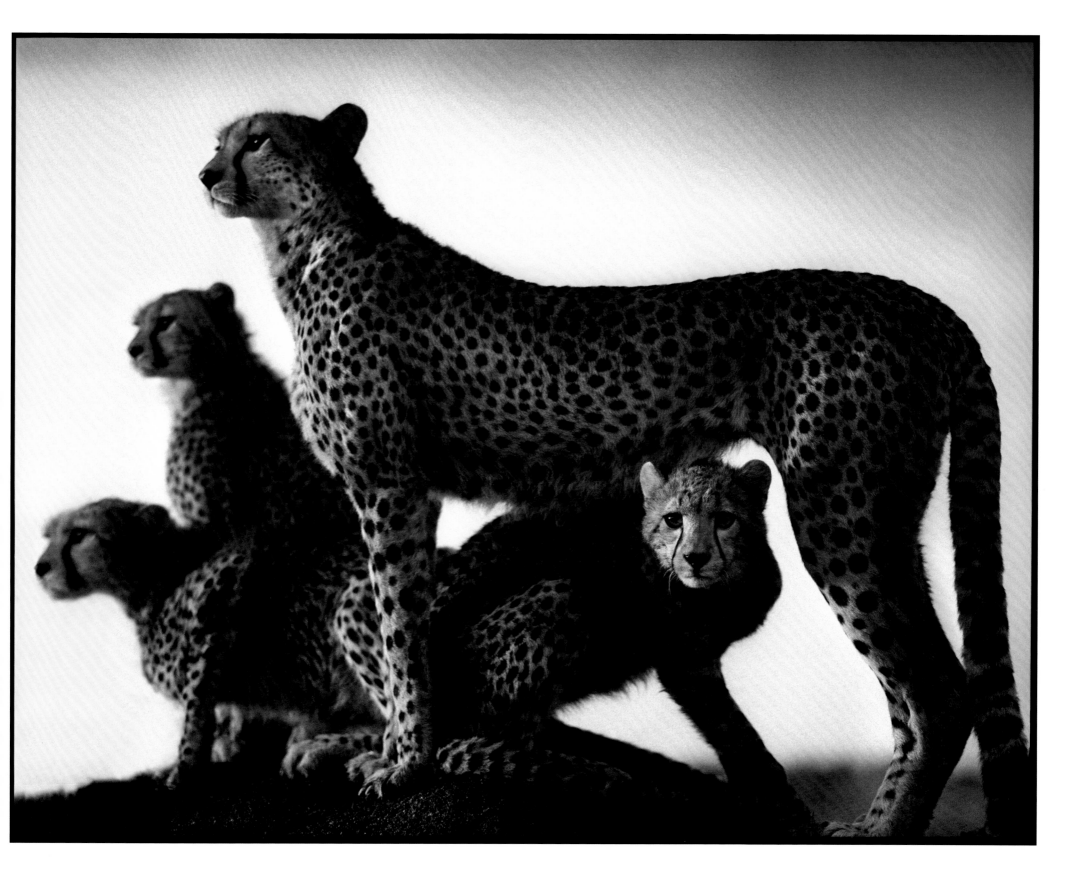

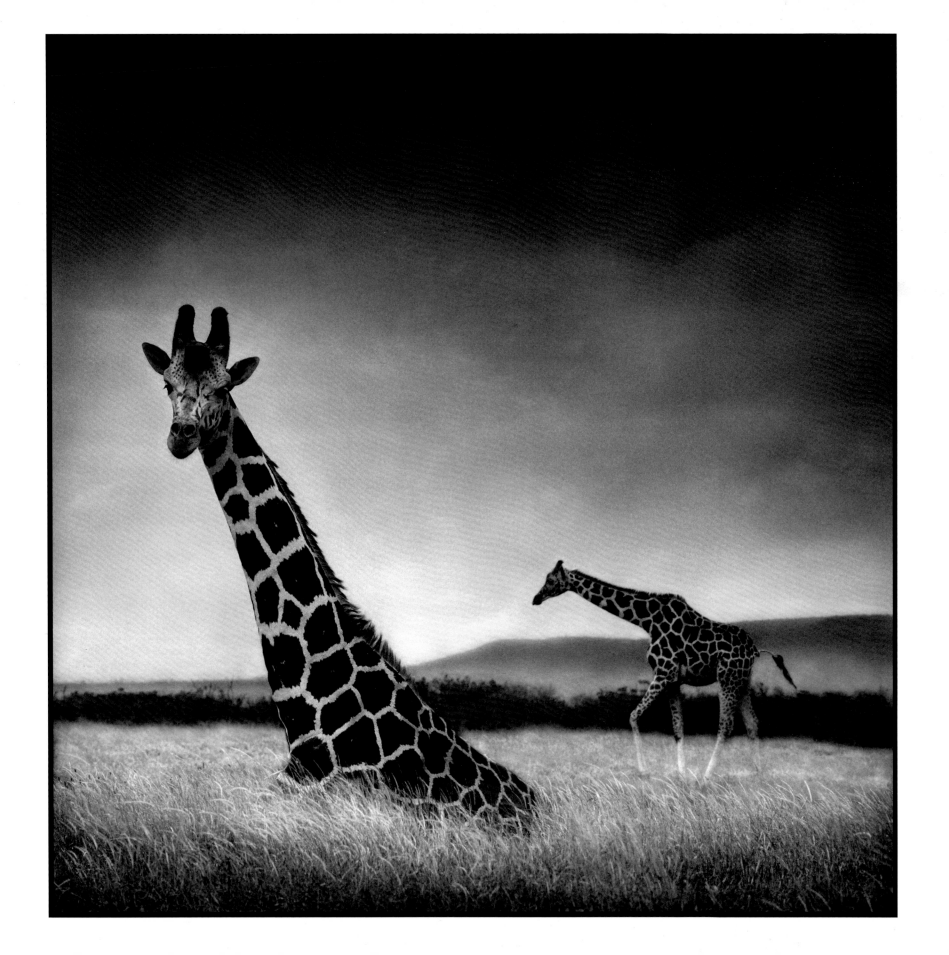

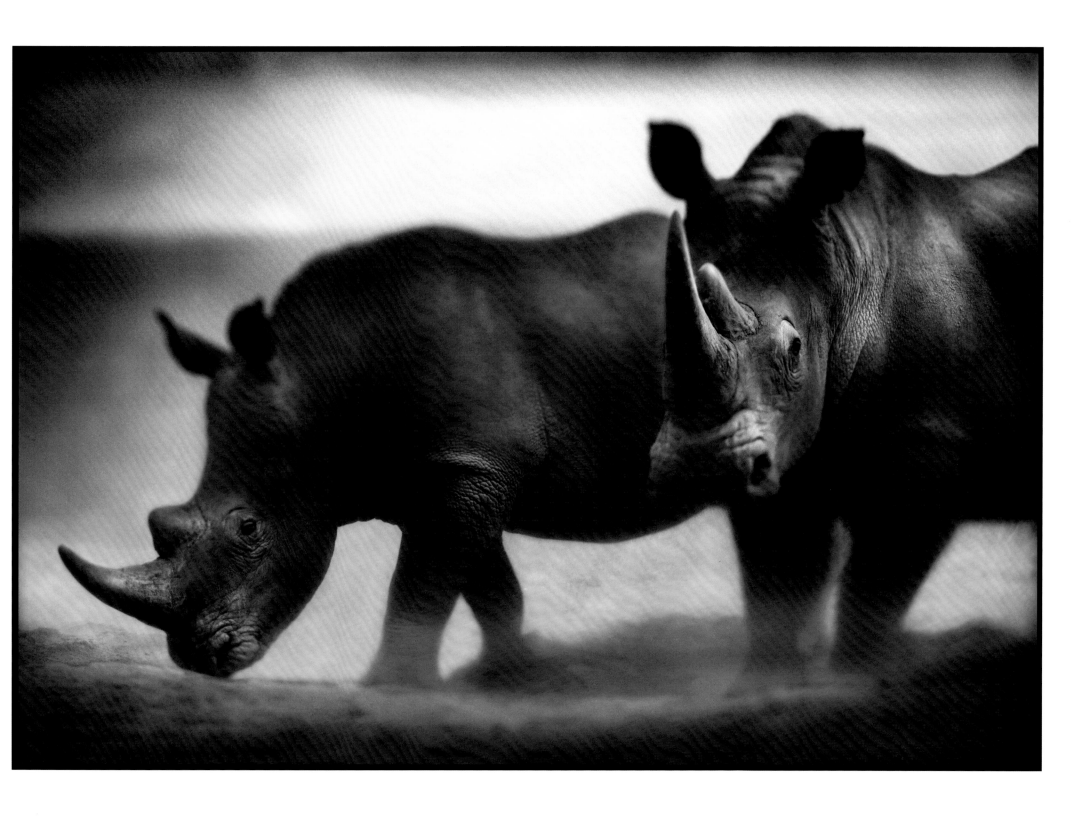

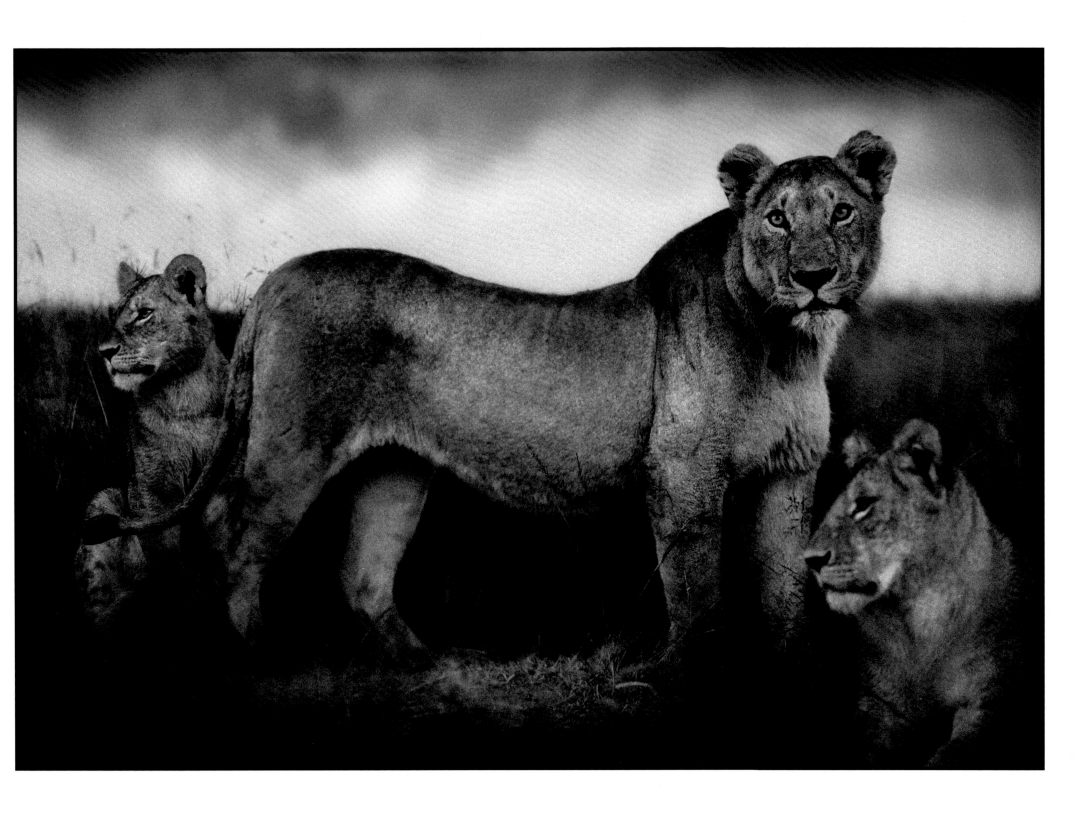

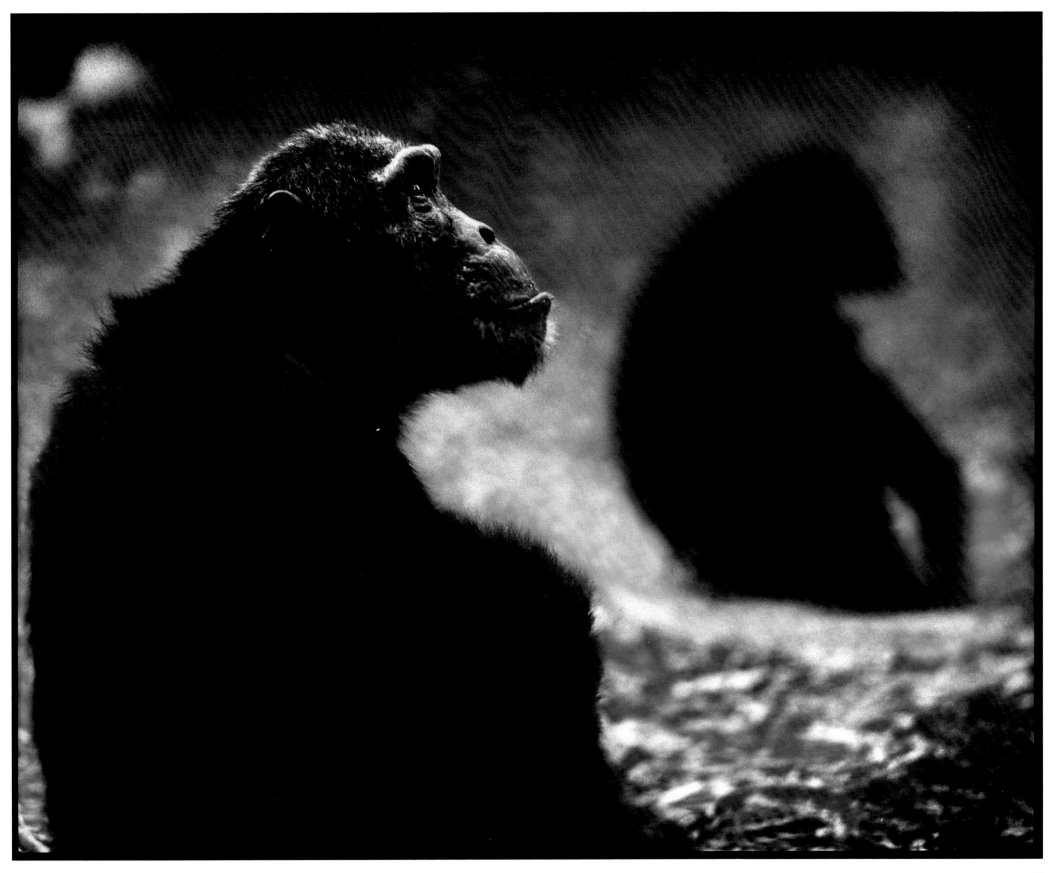

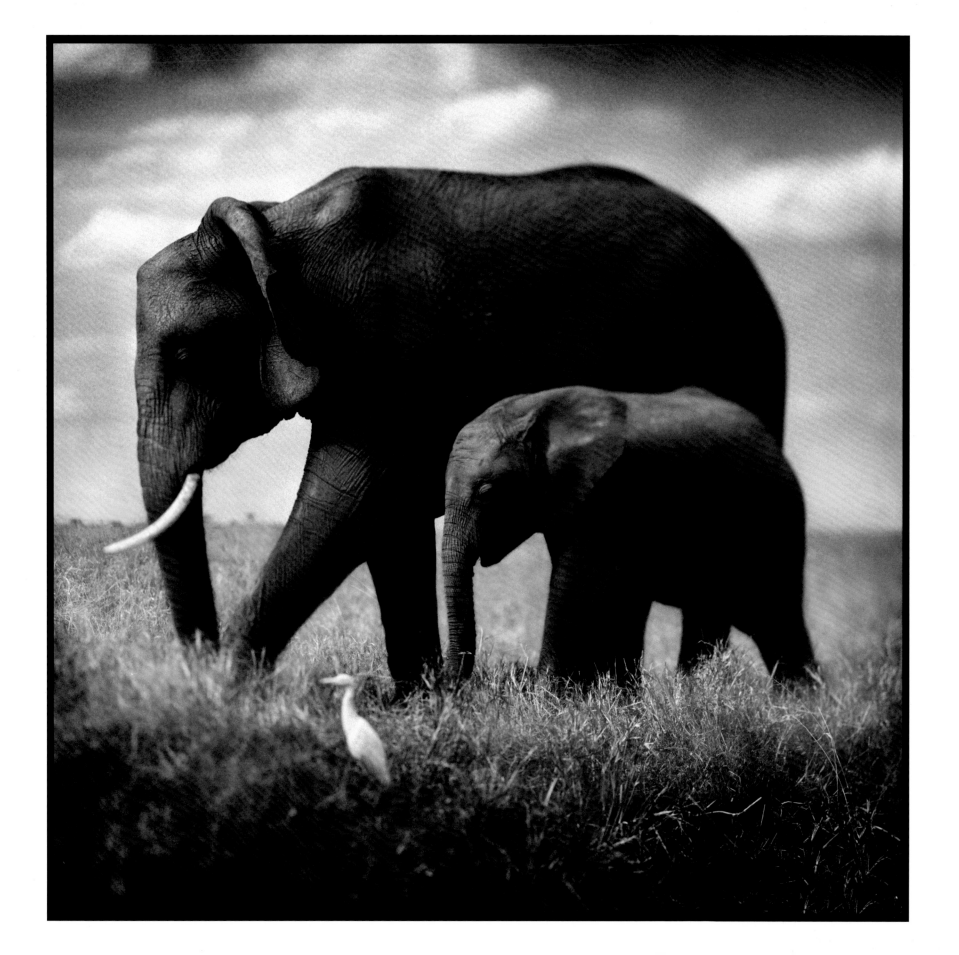

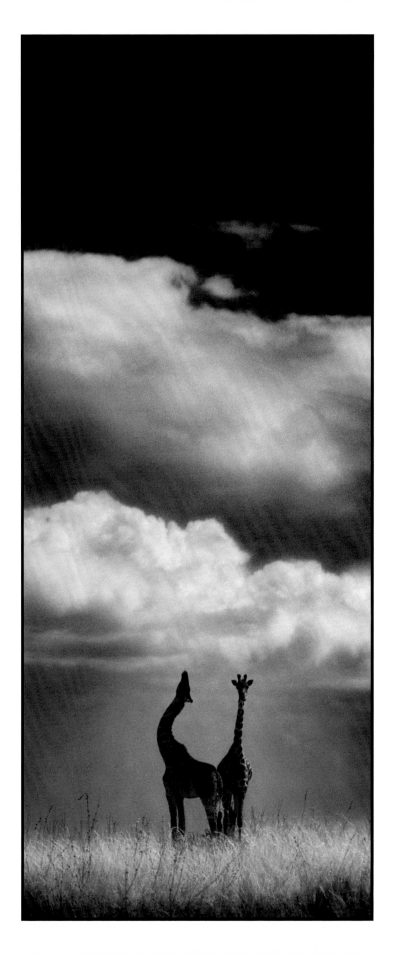

# AFTERWORD

This happened two days ago, near Lake Amboseli.

In the early evening light, a huge herd of elephants—some two hundred, more than I'd ever seen together—came softly toward me through the feathery grass.

As they glided by me, heading in the direction of the setting sun, the sound—an incredibly gentle, soft shuffle that completely belied their four-ton weight—was almost as sublime, as magical, as the sight. I tried to find a frame to capture the magnificent sight, but no angle—high or low or panoramic—came close to distilling the experience of these elephants. To try to capture with my camera the sheer beauty, poetry, and scale of the vision before me was, well, pointless. So I just sat back and let the long, gentle flow of elephants drift past me. A moment never to be photographed, but always remembered.

It's happened before, of course.

There was the early morning in January, on the southern Serengeti plains. A dozen giraffes were running together, with that extraordinary slow-motion grace, across the green velvet carpet of new grass.

I drove alongside the galloping giraffes, backlit against the Gol Mountains beyond, for a couple of miles. Speeding along at thirty miles an hour, I photographed the giraffes' semisilhouetted figures, high on the sight and the speed. But later, when I viewed the developed photos, I saw that, amid the clutter of legs and necks, nothing of that wonderful grace in motion had been captured in a single still image.

And there was the morning one August, in the rolling hills of the Maasai Mara. By then, I'd seen a few wildebeest migrations on the flat plains of the Serengeti to the south, but nothing, nothing had prepared me for the vision I saw up here: a vast medieval army of tens upon tens of thousands of wildebeests, spreading across each and every hill and valley for as far as I could see.

I panned my camera across this epic sight, looking for something to meaningfully frame. But it was utterly futile. I never even clicked the shutter.

Why begin this piece with my failure, as a photographer? Because it's one way I can perhaps begin to describe the extraordinary subject matter here. Of course, this book should bear witness to the fact that, on occasion, I have actually managed to click the camera shutter. There are even instances when something of the essence of that experience, at that moment in time, does permeate the final photo.

Perhaps some of the simplest, quietest moments, precisely because of their simplicity, result in photos that come closest to capturing the essence of being there, in that moment, with that particular creature. And many of these moments have been achieved by one not-so-simple thing: getting very, very close to the animals.

I don't use telephoto lenses. With a telephoto lens, the photographer is generally framing the animal against earth or scrub that has little poetry or beauty, whereas I want to see as much of the sky and landscape as possible. I want to frame the animals within the context of their environment, their world. I want to get a real sense of intimate connection with each of the animals—with that specific chimp, that particular lion or

elephant in front of me. I believe that being that close to the animal makes a huge difference in the photographer's ability to reveal its personality. You wouldn't take a portrait of a human being with a telephoto lens from a hundred feet away and expect to capture their soul; you'd move in close.

So I take my time and get as close as I can, inching my way forward little by little—either in car or on foot—often to within a few feet of the animals. And the more I feel like they're presenting themselves, posing for their portrait, the more I seem to like the final result.

To me, every creature, human or nonhuman, has an equal right to live, and this feeling, this belief that every animal and I are equal, affects me every time I frame an animal in my camera. With that in mind, I sometimes wonder what stops me from photographing the wild animals of North America, where I live; or from photographing my own dogs and cats; or from photographing farm animals, the most horrifyingly abused and maligned of all living creatures in the modern industrial world. Maybe one day I will photograph all these animals—those closer to home and less exotic, or the unseen billions of "raised-for-food" animals equally deserving of, but callously denied, a decent, humane life.

But for now, there in Africa, I find myself obsessively returning to those faces, those shapes, those landscapes, for there is something profoundly iconic, mythological even, about the animals of East and Southern Africa. There is also something deeply, emotionally stirring and affecting about the plains of Africa—those vast green rolling plains punctuated by graphically perfect acacia trees under the huge skies. It just gets you. Gets you in the heart, gets you in the gut.

Ultimately, I'm not interested in creating work that is simply documentary or filled with action and drama, which has been the norm in the field of the photography of animals in the wild. What I *am* interested in is showing the animals simply in the state of *being*. In the state of being before they no longer are. Before they cease to exist, in the wild at least.

My images are my elegy to these beautiful creatures, to this wrenchingly beautiful world that is steadily, tragically vanishing before our eyes.

And so it is that tomorrow morning I'll head back out once again to find the elephants, on their daily trek to water, to see if *this time . . . this time* I can capture on film the splendor and soul of these creatures, and the place they live.

For while it's still there, while the animals are still there, I'll keep trying. How could I not?

NICK BRANDT
Near Amboseli, Kenya

# INDEX OF PHOTOGRAPHS

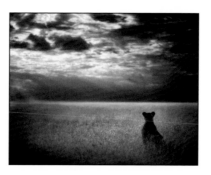

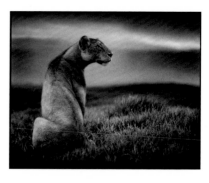

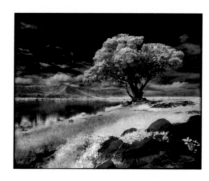

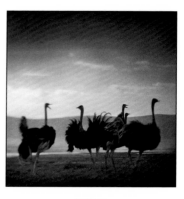

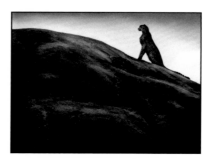

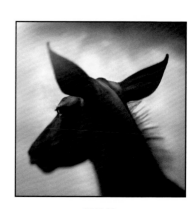

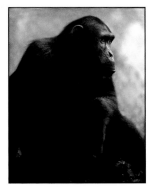

PAGE 25
Chimpanzee Posing,
Mahale, 2003

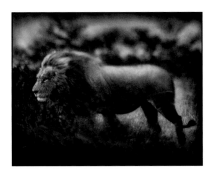

PAGE 27
Windswept Lion,
Serengeti, 2002

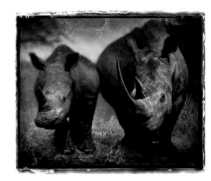

PAGE 28
Rhino Mother and Baby,
Lewa Downs, 2004

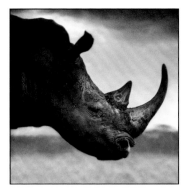

PAGE 29
Portrait of Rhino,
Lewa Downs, 2004

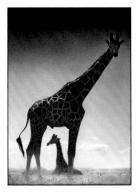

PAGE 31
Giraffe and Sitting Baby,
Aberdares, 2000

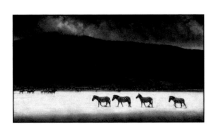

PAGE 33
Zebras Crossing Lake,
Ngorongoro Crater, 2004

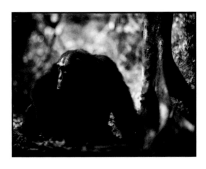

PAGE 34
Alpha Chimpanzee Pondering,
Mahale, 2003

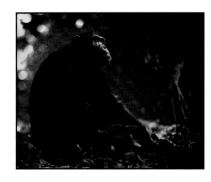

PAGE 35
Chimpanzee on Forest Trail,
Mahale, 2003

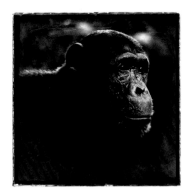

PAGE 36
Soulful Chimpanzee,
Mahale, 2003

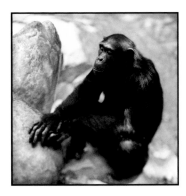

PAGE 37
Meditating Chimpanzee,
Mahale, 2003

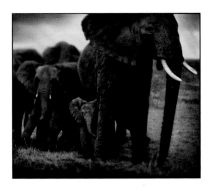

PAGE 39
Elephant Mother and Two Babies,
Serengeti, 2002

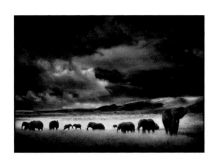

PAGE 41
Elephant Herd,
Serengeti, 2001

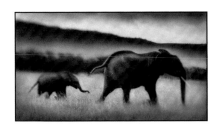

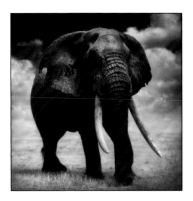

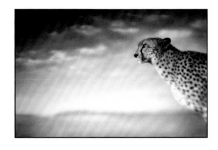

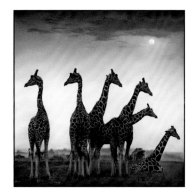

PAGE 42
Elephant Mother and Baby Running,
Serengeti, 2001

PAGE 43
Elephant Bull Portrait,
Amboseli, 2004

PAGE 45
Giraffe Fan,
Aberdares, 2000

PAGE 47
Cheetah Looking Over Plains,
Maasai Mara, 2004

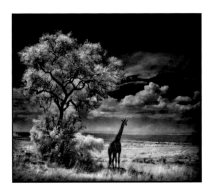

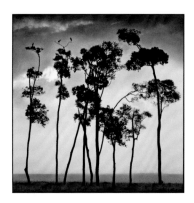

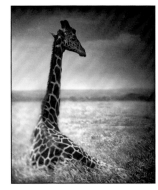

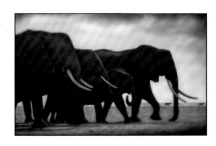

PAGE 49
Giraffe Looking Over Plains,
Serengeti, 2002

PAGE 50
Giraffe Sitting Alone,
Aberdares, 2004

PAGE 51
Storks in Treetops,
Maasai Mara, 2002

PAGE 53
Elephants Walking Across Lake Bed,
Amboseli, 2004

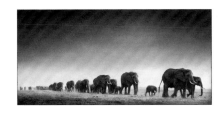

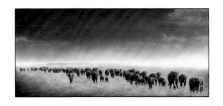

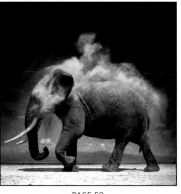

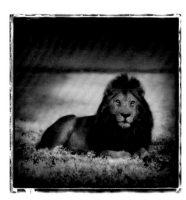

PAGES 54–55
Elephant Exodus I,
Amboseli, 2004

PAGES 56–57
Elephant Exodus II,
Amboseli, 2004

PAGE 59
Elephant with Exploding Dust,
Amboseli, 2004

PAGE 60
Lion at Dawn,
Naabi, Serengeti, 2000

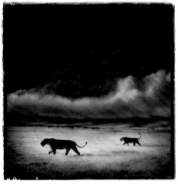

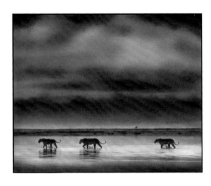

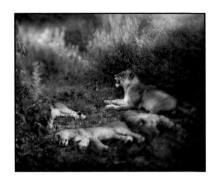

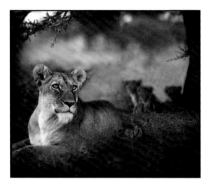

PAGE 61
Lionesses Crossing Crater,
Ngorongoro Crater, 2000

PAGE 63
Lionesses Crossing Lake,
Ngorongoro Crater, 2000

PAGE 64
Lioness with Sleeping Cubs,
Serengeti, 2000

PAGE 65
Lioness with Cubs under Tree,
Serengeti, 2004

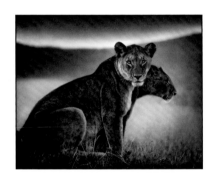

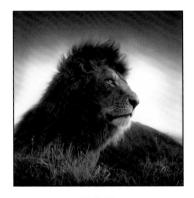

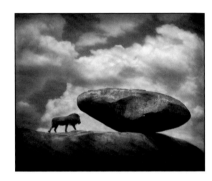

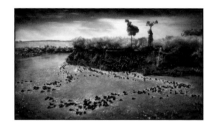

PAGE 67
Sitting Lionesses,
Serengeti, 2002

PAGE 68
Portrait of Lion in Grass,
Serengeti, 2002

PAGE 69
Lion on Rock,
Serengeti, 2000

PAGES 70–71
Wildebeest Crossing,
Maasai Mara, 2003

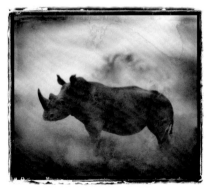

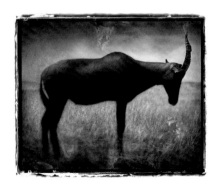

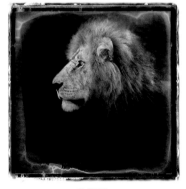

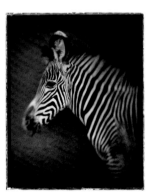

PAGE 73
Rhino in Dust,
Lewa Downs 2003

PAGE 75
Topi Bowing Head,
Maasai Mara, 2004

PAGE 77
Portrait of Lion,
Serengeti, 2000

PAGE 79
Portrait of Grevy's Zebra,
Lewa Downs, 2002

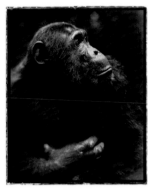

PAGE 81
Big Tusk,
Ngorongoro Crater, 2000

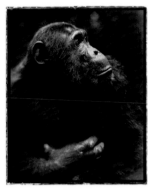

PAGE 82
Portrait of Old Chimpanzee
with Hand I, Mahale, 2003

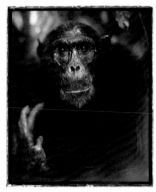

PAGE 83
Portrait of Old Chimpanzee
with Hand II, Mahale, 2003

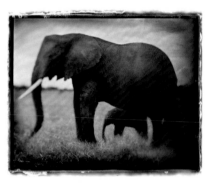

PAGE 84
Elephant Mother and Baby in Profile,
Serengeti, 2002

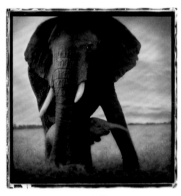

PAGE 85
Elephant Mother with Baby Holding Leg,
Serengeti, 2002

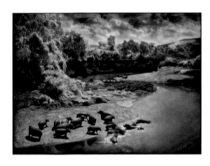

PAGE 87
Hippo River,
Maasai Mara, 2002

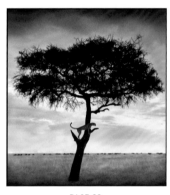

PAGE 89
Cheetah in Tree,
Maasai Mara, 2003

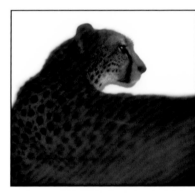

PAGE 91
Cheetah in Profile,
Maasai Mara, 2003

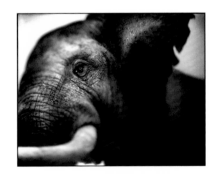

PAGE 93
Close-up of Old Mara Bull,
Maasai Mara, 2002

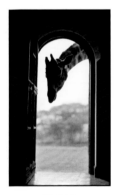

PAGE 95
Giraffe in Doorway,
Kenya, 2002

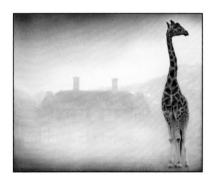

PAGE 97
Giraffe and Manor,
Kenya, 2002

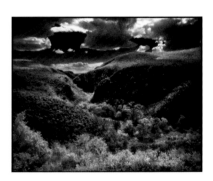

PAGE 98
Mukutan Gorge,
Laikipia, 2003

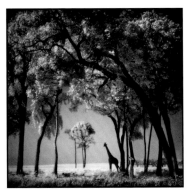

PAGE 99
Giraffe and Baby under Trees,
Maasai Mara, 2002

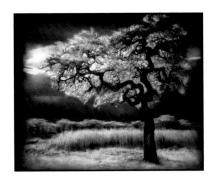

PAGE 100
Moonlit Tree,
Serengeti, 2002

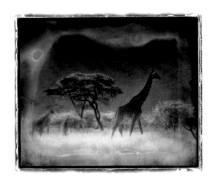

PAGE 101
Giraffe under Blue Moon,
Serengeti, 2001

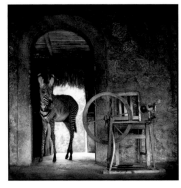

PAGE 103
Zebra in Doorway with Loom,
Lewa Downs, 2002

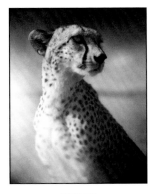

PAGE 105
Portrait of Cheetah against
Dark Sky, Maasai Mara, 2004

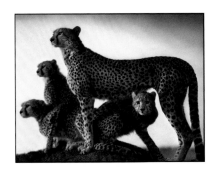

PAGE 107
Cheetah and Cubs,
Maasai Mara, 2003

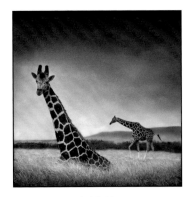

PAGE 109
Sitting Giraffe,
Aberdares, 2000

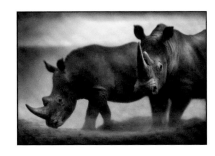

PAGE 111
Two Rhinos,
Lewa Downs, 2003

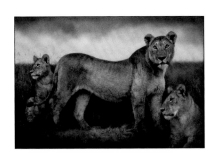

PAGE 113
Lion Family Portrait,
Maasai Mara, 2004

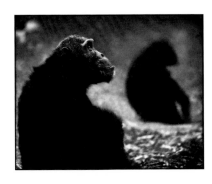

PAGE 115
Chimpanzee Monks,
Mahale, 2003

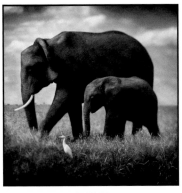

PAGE 117
Elephant Mother and Baby Walking
in Tandem, Maasai Mara, 2003

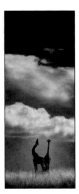

PAGE 119
Giraffe with Craning Neck,
Serengeti, 2002

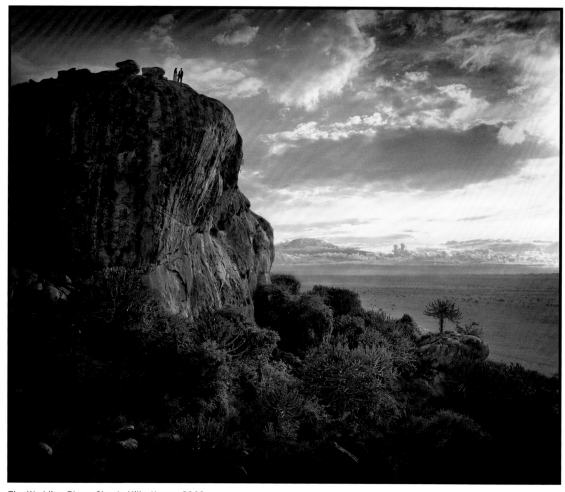

The Wedding Place, Chyulu Hills, Kenya, 2002

# THANK YOU

Orla, my wife, for all her love and support, and most particularly, her uncannily, unnervingly good judgment and taste during every step of the selection and printing.

Ninian Lowis and Mike Pelham, my amazingly tireless guides (and so much more) in Kenya and Tanzania, whose eagle-eyes sometimes see a good shot before I do.

Debra Heimerdinger of the Fong/Heimerdinger Gallery in San Francisco, who has been a voice of wisdom from the beginning.

Lara Lowis, for putting up with my endless requests over crackly radios and satellite phones for emergency extra film, immediate and wildly impractical processing, and on and on and on . . .

Jane Goodall and Alice Sebold for their generous words, and giving their time to write them;

Bridget Blake-Wilson, for letting me hog the best space in the Land Rover to get (arguably) the best photos during those first two trips to East Africa.

Ute Hartjen and Clemens Vedder of CameraWork in Berlin for giving me my first solo show, and their ongoing support.

Alan Rapp, my editor at Chronicle Books, for his great suggestions, ever-open mind, and much-appreciated patience.

Marla Kennedy for being the first in the fine art photography world to see my potential.

Also thanks to: Joe Berndt at Bowhaus for his invaluable help in enabling me to create prints exactly how I imagined them; Sloan Harris; Sascha Melein and Georg Klocker of CameraWork; David Unger and Cynthia Pett-Dante, for all their support over the years; Catherine Mills; Damien Bell, John Bearcroft and everyone at Sokwe; Peter Jones; Martin Hopely; Joslin Van Arsdale and Rixon Reed at Photo-Eye Gallery in Santa Fe; Beverly Feldman and Stephen Cohen of the Stephen Cohen Gallery in Los Angeles; Ben Burdett of the Atlas Gallery in London; Donna Linden and Shona Burns of Chronicle Books; and Michael Lok, for his skill and expertise in the printing of this book.

And finally, thank you to Mazzie, Scout, Frog, and Moscow, for reminding me daily (as if I needed it) of the joy of being in the presence of animals, and the endless fascination to be had in watching them; and thank you to all the animals seen in this book (especially the elephant mother with her baby in the Northern Serengeti), for being so wonderfully accommodating.

Library of Congress Cataloging-in-Publication Data available.

ISBN 978-0-8118-4865-7

Manufactured in China.

10 9 8 7 6

Chronicle Books LLC
680 Second Street
San Francisco, California 94107

www.chroniclebooks.com